MOViE
MAVERiCKS

MOViE MAVERiCKS

TRIVIA FROM THE FILMMAKING FRINGES

Jon Sandys

Huge thanks to my family and friends for their
support and contributions, also to all the visitors to
moviemistakes.com.

First published in Great Britain in 2006 by
Virgin Books Ltd
Thames Wharf Studios
Rainville Road
London
W6 9HA

ISBN 0 7535 11851
ISBN 9 780753 511855

The paper used in this book is a natural, recyclable
product made from wood grown in sustainable
forests. The manufacturing process conforms to the
regulations of the country of origin.

Typeset by Phoenix Photosetting, Chatham, Kent
Printed and bound in Great Britain by Bookmarque Ltd

CONTENTS

INTRODUCTION

I've been a film fan for a long time, and to me that doesn't just involve watching a lot of movies, it means taking an interest in how they're made and the people involved. Looking into a range of films made me realise that those which have the most interesting bits of trivia attached to them are generally those made by actors and directors who go their own way rather than always sticking to tried and tested formulae. It's true of the movies as a whole too – a massive blockbuster with a ton of computer effects tends to inspire less of a following than a low-budget horror whose memorable point-of-view shot of a low-level, fast-moving demonic presence could only be achieved by attaching a camera to a plank then the director and star running with it through a forest.

As such, it's those people and movies I've focused on – the mavericks of the movie industry, who inspire more fascinating movie facts than anyone else. Of course it's never as clear cut as that – at first glance some of the films listed here might appear to be purely mainstream, but that doesn't mean they haven't had a maverick's input. Steven Spielberg is a prime example – he may be a household name now, but he started with a low-budget thriller called *Duel* which has a cult following to this day. I'm firmly of the belief that if a maverick's nature doesn't get squashed by a big budget, it just gives them a greater opportunity to demonstrate it. Sam Raimi's another good example – a lot of people may only know him as the director of *Spider-Man*, but 21 years earlier he'd directed *The Evil Dead*, the low-budget horror I mentioned earlier. So just because a film might not strike you as an obvious candidate to be here, they've all got cult/classic/curious aspects to them.

You don't need to have seen all the movies listed here to enjoy what's written about them. In fact, in an ideal world, for every film listed here which you haven't already seen, you'll be inspired to see

it based on what's written about it, in the process making your own observations and discoveries. Before you know it, you'll be laying claim to maverick status yourself.

The book's broken down into different categories, as certain types of fact just naturally belong together. For example, where the inspiration for certain movies and scenes came from and how various special effects were achieved – you can always trust a maverick to take an unconventional approach! Within each category everything's listed alphabetically.

Anyway, enough rambling – I hope you enjoy reading this as much as I enjoyed putting it together.

TRADE MARKS

Certain directors have easily identifiable trade marks, which they work into some or all of their films. It would be a major undertaking to list everyone's little quirks, but four stand out from the crowd – Stanley Kubrick, John Landis, Sam Raimi and George Lucas.

Stanley Kubrick It doesn't appear in all his movies, but the phrase "CRM 114" features in four of his best-known films:

2001: A Space Odyssey – one of the space pods is labelled CRM-114.
A Clockwork Orange – Alex gets injected with serum (the word sounds a lot like CRM) 114.
Dr Strangelove – the message decoder is called the CRM-114.
Eyes Wide Shut – the room in the morgue to which Tom Cruise goes is in Wing C, Room 114.

John Landis He uses a fairly obscure line from *2001* – "See you next Wednesday" – in a lot of his films. Apparently his first script idea (of which nothing ever came) had the same title.

An American Werewolf in London – when David meets Jack and the zombies, it's used as the name of a porn film showing at a cinema that we can see.
The Blues Brothers – it's written on the big movie-ad sign (featuring King Kong) which a police car is hiding behind.
Coming to America – it appears on a film poster in the Underground station.
Spies Like Us – it's seen on a recruiting poster.
Trading Places – in this film, it's a movie poster in Jamie Lee Curtis's apartment.
Twilight Zone – The Movie – overheard in German.

🎥 **Sam Raimi** He always includes a yellow 1973 Oldsmobile Delta 88 somewhere in his films. It's not really worth listing every instance, as it's readily identifiable (for example, it's the car that Ash drives in the *Evil Dead* films, also the car that's used by Uncle Ben in *Spider-Man*). However, what's noteworthy is that it's only missing from one film he's made – *The Quick and The Dead*. Given that it's a western, the omission is possibly not surprising . . .

🎥 **George Lucas** The creator of *Star Wars* has spawned possibly the best-known and most widely reused trade mark – the number 1138. It originated as part of a title of a film that he made while a student, later remade as his first "proper" film, *THX 1138*. He's since incorporated the number into most of his films, and it's even been used by other people.

American Graffiti – John Milner's licence plate is "THX 1138".
Raiders of the Lost Ark – when Indy gets off the Nazi submarine inside the hidden dock, you can hear over the loudspeaker "Eins, eins, drei, acht." This is German for one-one-three-eight.
Star Wars – Luke says, "Prisoner transfer from block 1138" on the Death Star.
Star Wars: Episode I – The Phantom Menace – at the end, when all the robots power down, the droid that Jar-Jar Binks pushes over has four symbols on its back which look almost exactly like 1138.
Star Wars: Episode III – Revenge of the Sith – Clone Commander Bacara's number is 1138.
Star Wars: Episode V – The Empire Strikes Back – on Hoth, General Rieeken says, "Send Rogues Ten and Eleven to Station Three-eight."

SWEARING

Swearing has had a long history in film and, while of course I don't endorse it in day-to-day conversations, some films just wouldn't be the same without it. I came across enough F-word counts that I found myself intrigued by just which films used it the most – here are the Top Ten:

Casino – 422 times.
Born on the Fourth of July – 289 times.
The Big Lebowski – 281 times.
Pulp Fiction – 271 times.
Dead Presidents – 247 times.
The Boondock Saints – 246 times.
GoodFellas – 246 times.
Jay and Silent Bob Strike Back – 228 times.
Scarface – 218 times.
American History X – 205 times.

ACTORS AND ACTRESSES

A lot of actors appear in many films without ever inspiring bizarre stories or reports of odd coincidences. However, quite a few people out there either have interesting histories, have exhibited some very strange behaviour on set, or have just happened to be involved in something of note. This section's dedicated to them.

The scar on Harrison Ford's chin has been explained in two different ways in his films. When Young Indy is in the Lion's cart in *Indiana Jones and the Last Crusade*, he cracks a whip that cuts him on the top of his chin, hence Indiana's subsequent chin scar. In *Working Girl*, his character initially claims that he got the scar during a knife fight, then later admits that he once fainted and banged his chin on a toilet. The actual reason is that Ford lost control of his car when trying to put his seat belt on – and crashed.

Jason Lee dropped out of high school in order to become a professional skateboarder. He eventually retired from the sport in 1996, shortly after getting his big acting break in Kevin Smith's *Mallrats*, having been a pro skater for seven years.

Cult film director Edward D. Wood Jr was a US marine during the Second World War and took part in the assault on Tarawa. Apparently, he used to go into battle wearing women's red underwear beneath his uniform.

Air Force One One of the terrorists is played by an actor named Ilia Volokh. In the episode of *Friends* when Matt LeBlanc tried to put up a picture in his store he played the owner of a dry-cleaner's who claimed never to have seen *Air Force One*.

Alien vs Predator Lance Henriksen has now been killed or otherwise assaulted by the title creature of three major sci-fi franchises: a Predator, an Alien and a Terminator.

🎥 *Aliens* When Michael Biehn finds Newt, she bites him on his hand. The same thing happens to him in *Terminator* when he first meets Sarah Connor. It's the same hand that gets bitten as well.

🎥 *Batman Returns* Sean Young very much wanted the role of Catwoman. During pre-production she arrived at the studio in a Catwoman costume to talk to the makers of the movie. She employed other people to scout the studio grounds, using walkie-talkies to keep in touch with each other, in order to track down the producers.

🎥 *Blue Velvet* Several of the actors who were considered for the role of Frank found the character too repulsive and intense. Dennis Hopper, who ended up getting the part, was the one exception. He apparently said, "I've got to play Frank, because I *am* Frank!"

🎥 *Carnal Knowledge* When Jack Nicholson was preparing to act in his nude scenes, he'd warn everyone on set: "Here comes Big Steve!"

🎥 *Carrie* Director Brian De Palma originally wanted Sissy Spacek to play Chris Hargenson (subsequently portrayed by Nancy Allen). But Spacek wanted to be the star, so she showed up for her audition in a dress that her mother had made for her in seventh grade. She looked so awkward and hopelessly out of touch with fashion that De Palma cast her as Carrie.

🎥 *Charade* Cary Grant wasn't comfortable playing a romantic lead opposite an actress young enough to be his daughter. Jokes about the age difference were added to the script and it was made clear that he was the one being pursued, not the other way around. This put him more at ease.

🎥 *Collateral* Michael Mann described Vincent as someone who would be able to get in and out of anywhere without being recognised or remembered by anyone. To prepare for his part in the movie, Tom Cruise had to make deliveries for UPS in a crowded LA market, without anyone recognising him.

🎥 *Dead Ringers* Jeremy Irons plays twin brothers in this film. In order to keep track of whether he was playing Elliot or Beverley at any one time, he made sure always to play one with his weight on his heels and the other with his weight on the balls of his feet.

🎥 *The Deer Hunter* To acquire the withdrawn, hollowed-out look of his character, Christopher Walken ate nothing but bananas and rice during the weeks before filming started.

🎥 *Dr No* Ursula Andress was dubbed throughout the film by Monica van der Zyl, except when she sings "Underneath The Mango Tree" when she first appears. Her singing voice here was provided by actress Diana Coupland, best known for her role in the 1970s British sitcom *Bless This House*.

🎥 *El Mariachi* Director Robert Rodriquez spent a month in a clinic as a "test dummy" to earn the money to film the movie. He and his colleagues only had enough film for one shot per scene. Any mistakes that the viewer spots are due to the limited budget available, as the film-makers couldn't afford to reshoot anything.

🎥 *Evil Dead II* The person wearing the Henrietta costume is Sam Raimi's brother, Ted Raimi.

🎥 *For A Few Dollars More* Lee Van Cleef claimed that he was faster on the draw than the movie's star, Clint Eastwood. Van Cleef could draw his gun, cock it and fire in just three frames of film, or one-eighth of a second.

The French Connection Eddie Egan, the real police detective who inspired the character Popeye Doyle, plays Doyle's superior in the movie.

Friday The 13th Betsy Palmer was chosen to play Jason's mother only because she could provide her own transport to the set.

Full Metal Jacket R. Lee Ermey actually wrote all of Gunny Hartman's dialogue himself. Ermey was involved in a serious car accident just before shooting, so Kubrick invited him to stay at his house in England to recover. While recovering, Ermey read the screenplay over and over, and he remarked that the drill instructor's dialogue in the script was clearly the work of a screenwriter with a clichéd imagination who obviously had no idea what boot camp was really like. So Kubrick allowed Ermey to rewrite all the dialogue himself.

Ermey was convinced that the boot-camp scenes would have no credibility unless the actors were actually frightened of him. So the other actors in the film only saw him as the Gunny Hartman character. He never spoke, ate or fraternised with any of them unless it was during a scene. Much to Ermey's pleasure, the fear on the actors' faces is real. Many times during shooting the actors became so flustered by Ermey that they would blow their lines. Ermey recalls that he's seen other actors from the film around Hollywood from time to time, and they still won't speak to him.

Godzilla (1998) This movie features three actors who do voices on *The Simpsons*: Nancy Cartwright has a brief cameo as a receptionist, Harry Shearer plays Charles Caiman and Hank Azaria plays Animal.

The Gold Rush In the establishing shot of the gold-rush

miners, all the miners were played by homeless men hired off the street on the day of shooting.

The Good, the Bad and the Ugly Clint Eastwood wore the exact same poncho through all three "Man with No Name" movies. It was never replaced – or cleaned.

Jackie Brown The info on bondsman Max Cherry's ID (height, weight, eye colour, birth date, etc) is that of Robert Forster, the actor who plays him.

The Lion King In the movie Mufasa is voiced by James Earl Jones and the Lion Queen, Sarabi, is voiced by Madge Sinclair. Those same two actors also played the king and queen of Zamunda in the Eddie Murphy comedy *Coming to America*.

Live and Let Die This is the only Bond film to date not to include the character of Q – apparently the producers wanted to move attention away from Bond's gadgets. Desmond Lewellyn played "Q" in all the other films with the exception of *Die Another Day* (made after his death) and *Dr No*. In that film Peter Burton played "Major Boothroyd", Q's real name.

Logan's Run Michael York (Logan 5), Richard Jordan (Francis 7) and Michael Anderson Jr (Doc) were all over thirty years old when they made this film, the premise of which is that no one is allowed to live past the age of thirty.

Lost in Translation In the final moments of the film, Bill Murray whispers something to Scarlett Johansson. This entire scene was improvised, with no dialogue scripted: the two actors have refused ever to reveal what exactly was said – if, indeed, anything was.

🎥 *The Night of the Hunter* Robert Mitchum was very eager to get the part of the preacher in this film. During his audition, he particularly impressed director Charles Laughton when Laughton was describing the preacher character as "a diabolical shit". Mitchum promptly replied, "Present!"

🎥 *The Pianist* When director Roman Polanski won the Oscar for "Best Director" during the 2003 Academy Awards ceremony, he did not attend because of his Stateside statutory-rape conviction from 1977. If he ever returns to the United States, Polanski will be immediately arrested. In late 2003, during the Deauville Film Festival in France actor Harrison Ford presented the Oscar that Polanski had won in March.

To maximise the feeling of loss he needed to play the title part, actor Adrien Brody left his apartment, sold his car and didn't watch any television. He lost almost two stone for the role of Wladyslaw Szpilman by having a strict daily diet for six weeks: two boiled eggs and green tea for breakfast, a small amount of chicken for lunch, and some fish or chicken with steamed vegetables for dinner.

🎥 *Pink Flamingos* Actor Divine was arrested for stealing while shooting this film. As his defence, he claimed that he was a Method actor playing a criminal.

🎥 *Predator* Kevin Peter Hall, who plays the Predator, also appears as the pilot of the general's helicopter at the end of the film.

🎥 *Predator 2* With this film, Bill Paxton completed a notable sci-fi triple, being the first actor to be killed by an Alien, a Predator and a Terminator.

🎥 *Rocky III* Mr T was chosen for this role by Stallone himself – he spotted Mr T in a "world's toughest bouncer" contest (which

Mr T won). What impressed Stallone were Mr T's snazzy dressing, his no-nonsense attitude and his spectacular lingo. Apparently, the line that sold him on the idea of hiring T was Mr T's answer to the question "How do you handle potential troublemakers?" Mr T had his head shaved bald at the time, and his answer was "I tell dem fools that mah patience is as long as the hair on mah head." He was hired almost instantly. The role in *Rocky III* got him the spot in *The A-Team*, and the rest is history.

Run Lola Run While the film was being made, Franka Potente wasn't allowed to wash her hair for seven weeks because the red hair colour was very sensitive to water and would have been progressively washed out, wrecking continuity.

Sleepy Hollow Johnny Depp's main inspiration for Ichabod Crane was Richard E. Grant's portrayal of Withnail in *Withnail and I*.

The Tragedy of Macbeth In 1969 Roman Polanski's wife Sharon Tate was brutally murdered by cult leader Charles Manson. The next year, when production began on this film, crew members at one point suggested to Polanski that perhaps the film was too unrealistically gory. Polanski is reported to have replied, "I know violence. You should've seen my house last summer."

Trainspotting Jonny Lee Miller's character Sick Boy is obsessed with James Bond trivia. Miller is the grandson of Bernard Lee, who played "M" in the first eleven Bond films, until 1979.

AGES

We all know that twenty-somethings are frequently used to play teenage kids in high school, and provided they look the part it doesn't really matter anyway. But once in a while there's a sufficiently big (or small!) gap to make you amazed that you never knew their real ages before ...

Back to the Future Michael J. Fox is actually only ten days younger than his on-screen mother, Lea Thompson. He's also nearly three years older than Crispin Glover, the actor playing his father.

Bend it Like Beckham Parminder K. Nagra, who plays Jess, plays a seventeen- or eighteen-year-old in the film – she gets her A-level results part-way through. At the time of filming she was actually twenty-seven.

Family Business Sean Connery plays Dustin Hoffman's father, but is in reality only seven years older than him.

Ferris Bueller's Day Off Alan Ruck, playing the teenage Cameron, was thirty years old at the time.

Forrest Gump Sally Field is actually only ten years older than her on-screen son, Tom Hanks.

Grease Stockard Channing was thirty-four when Grease was being made, and she was supposed to be playing a teenager.

Harry Potter and the Chamber of Secrets The part of young Moaning Myrtle is played by Shirley Henderson, who is a thirty-seven-year-old woman.

📽 Indiana Jones and The Last Crusade Sean Connery was born in 1930 and Harrison Ford was born in 1942, yet they're supposed to be father and son. Jones Sr obviously developed early.

📽 The Manchurian Candidate Angela Lansbury plays Laurence Harvey's mother in this film, but in reality she is only three years older than him.

📽 Matchstick Men Alison Lohman, who plays Nicolas Cage's teenage (fourteen) daughter, is actually twenty-four.

📽 Mean Girls Amy Poehler, who plays Mrs George, is only five years older than her on-screen daughter, Rachel McAdams, who plays Regina.

📽 North by Northwest The actress playing Cary Grant's mother (Jessie Royce Landis) was born in 1904, the same year as Cary Grant. By some twisted logic, it was thought that casting Landis as Grant's mother would make Cary look young enough to be a believable love interest for Eva Marie Saint.

📽 Space Cowboys We first meet the characters in the year 1958 when they are test pilots. In real life Tommy Lee Jones was about twelve years old in 1958. Eastwood, Garner and Sutherland would have been in their mid to late twenties in 1958.

BACKGROUND OBSERVATIONS

Very often in films, the main action is going on in the foreground, as you'd expect. But if you occasionally pay attention you'll be amazed at what you can see or hear in the background. Often things have been deliberately slipped in by the director, but some completely unexpected background disturbances crop up as well . . .

AntiTrust In the news bulletin at the end, three of the bad guys are named as Solskjaer, Sheringham and Schmeichel – the names of three football players who at the time played for Manchester United. Director Peter Howitt is from Manchester.

Back to the Future When Marty first goes back in time, the mall is called "Twin Pines Mall". In 1955 he runs over one of "old man" Peabody's pine trees. On his return to 1985 the mall is now called "Lone Pine Mall".

Back to the Future Part II In the scene where Marty is scared because of the holographic picture of the shark coming from the cinema showing *Jaws 19*, if you look closely you can see "Directed by Max Spielberg". Steven Spielberg, who directed the first *Jaws*, has a son named Max.

Batman Look at the picture of "Batman" that the artist shows Knox to make fun of him (the one of the bat dressed up in a suit). In the lower-right corner of the paper is the autograph of Batman creator Bob Kane.

The Joker says "better make it ten [minutes]", before heading up Gotham Cathedral. Exactly ten minutes later, the helicopter flies into shot to get him.

📽 ***The Big Lebowski*** At the beginning of the movie, when The Dude is writing a cheque for the cream at the grocery, look at the date on the cheque – September 11, 1991. A few seconds later we see George Bush Sr talking about Iraq. So here we have a scene containing September 11th, George Bush (one of them) and references to the Middle East in a movie that takes place in 1991.

📽 ***Blade Runner*** Where Deckard and Gaff are heading towards police headquarters in a spinner, the *Millennium Falcon* can be seen in the bottom-left corner of the scene, disguised as a building. The model was built as a personal project by one of the model builders working on the film, and it was a last-minute decision to use it as a building.

📽 ***The Blues Brothers*** Notice the graffiti on the bridge that the Blues Brothers use to hide the car. One of them is "John (heart) Debbie". This is a reference to the director, John Landis, and his wife Deborah.

📽 ***Catch Me If You Can*** Towards the end of the movie, when Hanratty is briefing his staff on a fraud suspect, you can see written on the chalkboard next to Hanratty, at the bottom left, "Steven and Tom's 4th project". "Steven" refers to the film's director Steven Spielberg; "Tom" refers to Tom Hanks, who plays Carl Hanratty – Frank Abagnale's pursuer – and "4th project" means that this film was Spielberg's and Hanks's fourth film together.

📽 ***Charlie and the Chocolate Factory*** Some of the buttons in the glass elevator which are never used: Stars in their Pies, Incompetent Fools, Dessert Island, T-Bone Steak Jell-O, Secretarial Poodles, Cocoa Cats, Mighty Jam Monitor, Mechanical Clouds, Nice Plums, Up And Out, Fragile Egos, Black Box of Frogs, Weird Lollipops, Creative Dog Flip, Pie Cream, Elastic Forest, Leaky Canes, People Poo and Spewed Vegetables.

🎥 *Clerks* During the scene where Dante and Veronica are arguing about their sexual experiences, a woman comes up to the counter with two items – vaseline and rubber gloves.

The disgusted customer in the scene when Dante and Randal are discussing how to clean glass in a nudie booth is buying paper towels and glass cleaner.

🎥 *Donnie Darko* When Donnie's mother calls to say that they'll be going on the red-eye flight, the announcement heard in the background at the airport says that Flight 2806 is boarding at Gate 42 and leaving at 12 a.m. A subtle reference to the countdown that Frank gives Donnie – 28 days, 6 hours, 42 minutes, 12 seconds.

🎥 *Equilibrium* The muzzle flashes from Cleric Preston's pistols appear in the shape of the Tetragrammaton insignia in several of the gun battles: first, in the night-time battle over the dog, when Preston first fires his pistol; secondly, several times during the hallway battle near the end of the film (most noticeably just before and after the pistols are reloaded from the wrist-loaders); and, finally, when Preston fires the single shot that executes Dupont.

🎥 *Fear and Loathing in Las Vegas* Near the start of the film, when Dr Gonzo and Raoul are driving along the highway, there is an accident involving a lot of cars. A person covered with a white sheet in the pile-up is about to be put in an ambulance – there is a smiley face in blood on the white sheet.

🎥 *Fight Club* When Edward Norton is putting "Marla" on the bus, in the background there is a movie theatre playing *Seven Year in Tibet* [sic] (with Brad Pitt). Further down across the street was another marquee for *Wings of the Dove* (with Helena Bonham Carter), but this isn't visible in the final film.

There are several scenes where Edward Norton sees Brad Pitt for a split second before he actually meets him (not counting when he passes him on the escalator): by the photocopy machine, talking to the doctor, the testicular cancer group, Marla in the alley, and then when watching TV when the waiters say "Welcome."

🎥 **The Fugitive** After his escape, Harrison Ford gets on a train marked with the name "Kimball" and then, in the next shot, a helicopter flies over a hotel called "Harrison".

🎥 **Get Carter** Early in the film, when Jack Carter is in the bar and asks for a "a pint of bitter ... in a thin glass", there's a brief shot of an old man raising his pint glass to the camera. The old guy has six digits (five fingers and a thumb) on his hand.

🎥 **Goldeneye** When Bond is playing baccarat with Xenia, his last hand – and his only winning hand against her – is two face cards and a six. In baccarat, face cards and tens are worth zero and cards under ten are worth their number. So his cards are, in order, 0-0-6, the code number of his lost friend Alec Trevelyan (006).

🎥 **Gremlins** While the father is at the inventors' convention talking on the phone, the machine from the 1960 version of *The Time Machine* can be seen in the background, winding up to full power. The scene cuts back to the house, and when we come back to the convention the machine has gone, leaving only a wisp of coloured smoke.

🎥 **Hannibal** There is a vegetarian cookbook on top of the refrigerator against which Hannibal has trapped Clarice. There is also a guide to Southern cooking.

At the end of the opening credits, just after "Screenplay by David Mamet" and before "Directed by Ridley Scott", on the right-hand

side of the screen a group of pigeons form an impression of Hannibal's face.

In the scene where the pickpocket is trying to get Hannibal's fingerprint on his bracelet, the cinema in the background has a poster for *Gladiator* – also directed by Ridley Scott.

🎥 *Harry Potter and the Chamber of Secrets* As Hagrid and Harry are walking away from Knockturn Alley, in one of the shop windows in the background, there is a set of the Harry Potter books.

🎥 *High Fidelity* When Rob and Laura are lying in bed listening to Ray a.k.a. Ian having sex, Laura is reading a book called *Love Thy Neighbor*. Later on we learn that Laura did indeed love her upstairs neighbour.

🎥 *The Hitchhiker's Guide to the Galaxy* At the very end of the film, when the group uses the Improbability Drive to go to the Restaurant at the End of the Universe, there are a lot of images that flash onto the screen when the drive is activated, as in the other parts of the film. In this case, the very last image shown is the face of Douglas Adams, the creator of the *Hitchhiker* series.

The rather old-fashioned car that Ford tries to introduce himself to and nearly gets run down by is a real Ford Prefect. Ford's surname isn't mentioned in this film as the Ford Prefect was never sold in the US, so American audiences wouldn't get the joke.

🎥 *Home Alone 2: Lost in New York* When Kevin first arrives in New York and does all his sightseeing there is a point where he is standing in front of Radio City Music Hall. He turns his back to it and takes a picture of whatever is across the street. He would really just be taking a picture of the side of an anonymous building – there is nothing pictureworthy across from Radio City.

🎥 ***The Incredibles*** The phone number on Mirage's business card is 866-787-7476. The last seven digits spell out SUPRHRO (Superhero) on a phone touch pad.

🎥 ***Jaws*** In the scene when the three guys are out on the boat in the dark looking for the shark, a meteor shoots past Roy's right shoulder. This was a real one that happened to be caught on film. In the next few frames another meteor shoots across the top of the shot: this was added later for effect.

🎥 ***Jeepers Creepers*** When the Creeper picks up the male police officer's head to eat the tongue, the slogan on the large billboard behind him reads: "Oooh, it tastes so good!"

🎥 ***Labyrinth*** In the scene inside Sarah's bedroom, many of the objects in her room resemble people or obstacles that she meets in the Labyrinth. For example, the bookends holding up her books look like Hoggle, she has a toy maze (labyrinth) and the doll in the music box is dressed in a miniature version of the same dress that Sarah wears at the ball. The music box also plays the tune of the song that Jareth sings to her at the ball.

🎥 ***The Lion King*** After Timon and Pumbaa laugh at Simba for saying that his father was watching him, Simba walks away and lies down. When he does, stuff flies everywhere and many people think that it forms the letters "SFX" in the sky as a tribute to the special-effects team. Others choose to believe that it spells out "SEX".

🎥 ***Lock, Stock and Two Smoking Barrels*** Just after Bacon orders "Three of your most refreshing drinks", a football commentary being played in the background describes the film's director Guy Ritchie as playing on the wing.

🎥 *The Matrix Revolutions* At the end of the movie where the Oracle is talking to the Architect, there is a plaque on the bench that she is sitting on which says "In memory of Thomas A. Anderson".

🎥 *Minority Report* When John kidnaps Agatha, Danny Witver asks, "How much time do we have?", referring to the time left before John has been predicted to commit the murder. A Pre-Crime Officer tells him, "Fifty-one minutes, twenty-eight seconds." This is precisely the time remaining until the film ends, excluding the credits.

🎥 *Monsters, Inc.* Watch the end of the credits. Anybody else see all the names on the "Human Child Scream Research Team"? What a cool job, making kids scream.

At the very end of the credits, there are a couple of lines that say "No monsters were harmed in the production of this motion picture."

🎥 *Monty Python and the Holy Grail* After the villagers weigh the witch to see if she weighs the same as a duck, and then the scales balance, watch the scales after they drag her off to be burned. The side which contained the duck is obviously loaded to start with, as it sinks lower than the other pan when there is supposed to be nothing on the scales. Hence the witch weighing "the same" as the duck, and seemingly proving that the villagers rigged the whole thing.

🎥 *Napoleon Dynamite* After Uncle Rico throws the steak at Napoleon when he's riding his bike, Rico sits back down on the porch, discreetly spits something into his hand and puts it down. According to the DVD commentary he was spitting out the bite of steak that he was eating because Jon Gries, who played Uncle Rico,

doesn't eat red meat. Between shots he spat out all the many bites of steak that his character had to eat.

🎥 *A Nightmare on Elm Street Part 2: Freddy's Revenge* A close look at the bus driver at the beginning of the movie reveals Robert Englund without his Freddie make-up/costume.

🎥 *Not Another Teen Movie* In the scene where the three boys try to see into the girls' locker room, just before they climb in the vent there is a shot of it. Underneath it is a sign that reads "Vent to Girls' Locker room – capacity 2 adolescent boys".

🎥 *Ocean's Eleven* Rusty Ryan is eating in nearly every scene that he is in. On the DVD, there is a commentary by Brad Pitt in which he says that during filming he realised that since his character is so busy he would have to eat whenever he got a chance. So he and the director decided to have him eating in every scene.

When Rusty rejoins the poker game to find that Danny has joined them, Danny talks to one of the people about making the jump from TV to movies and how difficult it must be. That's what George Clooney (Danny) did when he left *ER*.

🎥 *The Phantom of the Opera* In Carlotta's dressing room there is a large portrait of Carlotta holding Andrew Lloyd Webber's head on a plate.

🎥 *Pulp Fiction* When Vincent takes Mia to Lance's house to give her the adrenalin shot, two board games are visible in the background. They are appropriately *Operation* and *Life*.

🎥 *Red Heat* When Schwarzenegger and Belushi are in the diner after shooting the transvestite, Belushi is going through the paperwork that needs to be done. Belushi says the one sheet which

we see, is an "accident report". Actually typed at the top of the paper is "Worthless Document Case Report".

📽 *Reservoir Dogs* After Mr Orange passes out, Mr Pink and Mr White go into the next room to talk. On the counter are containers of white liquid and pink liquid next to each other, with some orange liquid further away on the other side of the counter.

📽 *RoboCop* After the cops have gone on strike and the bad-guy entourage meets downtown, Clarence gets a call about the location of RoboCop. He slams the door to his 6000 SUX and you can see the rear-view mirror fall right off.

On the original version of the DVD box set, a warning is shown: "Any unauthorized duplication, distribution or exhibition of *Robocop* will result in criminal prosecution by Enforcement Droids."

📽 *RoboCop 2* When RoboCop is being reprogrammed, various information flashes up on screen, only really readable if watched frame by frame on a DVD. Various new directives come up, including "Avoid Orion meetings" (Orion being the company that made the film). The names "Kuran" and "Lockwood" are shown among the electronic-text garbage, indicating Peter Kuran and George Lockwood, two members of the special-effects team. There's also a string of numbers, which when treated as Hex and translated to ASCII comes out as "Pete Kuran is a great guy."

📽 *Secret Window* When Mort smashes the shower door, there's a hole left in the glass. The hole looks very similar to a small four-legged animal with a screwdriver in its neck. In the movie, that's how Shooter kills his dog.

The Shining In the scene where Jack is writing and gets mightily upset when Wendy interrupts him, the chair behind Jack vanishes and then reappears. This is, however, Kubrick's deliberate intention. The audience is supposed to get a subconscious feeling that something is wrong.

The Sixth Sense Every time dead people are close by, there is something red in the preceding scene. For example, when Cole is at the birthday party and is about to get trapped in the attic with the ghosts, there is a red balloon rising towards the ceiling; when Graham comes home to his sleeping wife and is about to realise that he too is dead, she is wearing a red throw; when Cole is in the car with his mother and there is an accident up ahead, she is wearing a red sweater. And so on.

Spider-Man During the Thanksgiving dinner that occurs right after the fight in the burning building, Peter is wearing a green shirt and Norman wears a blue shirt with a red tie. Also, Harry is wearing all the colours – green shirt, red tie and blue coat.

The wallpaper in Peter's bedroom is blue with little spider webs on it.

Star Wars In the bar on Tattooine (where Luke and Obi-Wan meet Han Solo), there are lots of aliens at the bar. In the background of these shots there is a NASA astronaut in full space-walk gear (helmet, etc.) walking across the back of the shot, complete with American flag on his arm.

Star Wars: Episode II – Attack of the Clones In the pursuit scene on Coruscant, when the two speeders are diving, there is an X-Wing pursued by three TIE fighters in the traffic on the ground.

Star Wars: Episode III – Revenge of the Sith As Obi-Wan and Anakin safely drop off Palpatine, at the Jedi Council building on Coruscant, at the lower right-hand corner of the screen the *Millennium Falcon* is landing.

Terminator 2: Judgment Day When the T-1000 follows the helicopter, there is a clear indication at one point that the pursuer has three arms, when it is loading its gun with two arms and steering with the third.

Terminator 3: Rise of the Machines When the Terminator reboots himself in the hangar in order to get rid of the influence of the T-X, the scrolling text includes "Quicktime Player – Access" and "MP3.com – No Access".

The Usual Suspects The personal biographies of the characters are handed out in the order in which they die.

Willy Wonka & the Chocolate Factory When the newsreader announces the finder of the fraudulent fifth ticket, the picture he holds up is actually that of one of Hitler's best-known henchmen, Martin Bormann.

BEFORE THEY WERE FAMOUS

Not everyone manages to pull off what Cameron Diaz did – her first film role was in *The Mask*, where she not only gave a great performance but also made one of the best entrances in cinema history. Most people start way down the list, taking what work they can get, hoping for a big break. Here's where some people made their debuts . . .

🎥 *Animal House* Kevin Bacon's first film – he's seen a few times, most memorably as the new admission, being beaten while saying, "Thank you, sir, may I have another?"

🎥 *Annie Hall* This film marks Sigourney Weaver's screen debut. She plays Woody Allen's date towards the end of the film, and has no lines.

🎥 *Back to the Future Part II* When Marty is waiting for Griff in the cafe he plays a videogame with two young boys. One of the boys is a very young Elijah Wood.

🎥 *Buffy the Vampire Slayer* When Buffy is cheering at the basketball game and Grueller (now a vampire) shows up, he growls at a player from the other team. The player then tells him, "Here, take it" and hands him the ball. The player from the other team (in the red) is Ben Affleck, pre-stardom.

🎥 *Coming to America* The man who is getting a haircut as Akeem first enters the barber shop is played by a then unknown Cuba Gooding Jr.

🎥 *Death Wish* A very young, tall and thin Jeff Goldblum plays one of the thugs who murder Charles Bronson's wife. He is credited as "Freak 1".

🎥 *Edward Scissorhands* In the scene where Edward is being driven into town, the car passes a house with children playing on a slip-'n'-slide on the front lawn. The boy who is seen running and sliding is future Backstreet Boy Nick Carter.

🎥 *Enter the Dragon* In the dungeon scene where Bruce Lee battles some of the guards in front of jail cells packed with prisoners, he snatches one of the guards by the hair and snaps his neck. The poor guard was a then eighteen-year-old Jackie Chan.

🎥 *Fast Times at Ridgemont High* This is Nicolas Cage's first film (the only time he's credited as Nicolas Coppola, his real name). You can see him at the beginning talking to Judge Reinhold just before somebody throws something at him. He is also at the restaurant looking up from behind the grill when the customer is yelling at Brad.

🎥 *Field of Dreams* Then unknown, Ben Affleck and Matt Damon are among the thousands of extras in the Fenway Park scene.

🎥 *Friday* In the flashback scene where Red is about to get knocked out by Deebo, you can see Michael Clarke Duncan, better known as John Coffey in *Green Mile*, kneeling next to Deebo, rolling dice.

🎥 *The Godfather* The baby used in Michael and Kay's baby-christening scene is Sophia Coppola, Francis Ford Coppola's daughter.

🎥 *The Graduate* When Elaine finally tracks down Ben in his gloomy room and he makes her scream, some of the other tenants group behind the landlord in the doorway. One of them says, "Shall I get the cops? I'll get the cops …" This actor is a young Richard Dreyfuss.

Hook Gwyneth Paltrow plays the young Wendy.

Little Darlings The long-haired "flower girl" called Sunshine is Cynthia Nixon, a.k.a. Miranda on HBO's *Sex and the City*.

Mystic Pizza When Daisy is having dinner with her boyfriend's family, check out the younger brother at the table – it's a then unknown Matt Damon.

National Lampoon's Vacation Little cousin Vicky with the blonde hair is played by Jane Krakowski, who later became well known for playing Elaine in *Ally McBeal*.

Network At the very start of the credits, just after "Metro Goldwyn Mayer" disappears, Karen Allen walks across screen, in her very first film role.

Night Shift Two up-and-coming stars in this movie: Shannen Doherty is the Bluebell (Girl Scout) in the elevator scene and a very young Kevin Costner is Frat Boy #1 in the fraternity-party scene.

Superman Something for *Cheers* fans: John Ratzenberger (Cliff) is an extra, playing a control-booth worker.

Twins In the opening scenes, an uncredited Heather Graham plays the mother of the title characters.

Working Girl A very young David Duchovny makes his movie debut. He is one of Tess's surprise birthday-party friends in the far left-hand side of the closet.

CAMEOS

In some movies, the camera will linger a fraction too long on someone who at first glance seems to be a random extra. Sometimes that's true, but sometimes it turns out to be a cameo appearance by someone famous, or who has some other sort or involvement in the film ...

1941 In the USO, when the soldiers and sailors are squaring off on the dance floor one of the sailors is James Caan, who was filming another movie nearby and had some time to kill. When the fight starts, he throws the first punch.

The soldier covered in mud who gets his motorbike stolen from in front of the cinema is played by director John Landis.

2001: A Space Odyssey The little girl seen on the videophone is director Stanley Kubrick's daughter.

2010 When Roy Scheider is talking to his associate on the bench in front of the White House, there is a long-shot of a person feeding pigeons. It is none other than Arthur C. Clarke in a cameo appearance.

American Pie 2 In the scene where Casey Affleck answers a phone call as a young executive, the two people in the back are J.B. Rogers, who directed the film, and Adam Herz, who wrote it.

An American Werewolf in London Near the end of the movie when David – as a werewolf – terrorises Piccadilly Circus, a man standing in front of a store window is knocked backwards and falls through the glass. Believe it or not, this man is none other than the film's director, John Landis.

🎥 *Apollo 13* The captain of the *Iwo-Jima* to whom Tom Hanks is talking at the end of the movie is the real Jim Lovell. Ron Howard had asked him if he'd like to appear in the film as an admiral, but Lovell said, "I retired as a captain; a captain I will be."

🎥 *Bad Boys II* When Mike and Marcus need to commandeer a car for a chase, the driver of the first car that they stop (which they eventually let go in order to get a better car) is director Michael Bay.

🎥 *Bill & Ted's Bogus Journey* The actor who plays Death (William Sadler) also appears as a man who is watching the Battle of the Bands on television with his wife near the end of the movie.

🎥 *The Birds* When Melanie first goes into the pet shop Alfred Hitchcock walks out. He is walking two small dogs, his real-life pets.

🎥 *Blade* During the chase with Officer Krieger, the vampire on the side of the road who is biting the girl's neck is actually director Stephen Norrington.

Stan Lee filmed his regular cameo for Marvel films but it was eventually cut. He was going to play one of the policemen who come into the club at the end of the opening scene, discovering Quinn's body on fire.

🎥 *Born on the Fourth of July* The real Ron Kovic appears in the opening Fourth of July parade scene as one of the disabled veterans.

Director Oliver Stone can be seen briefly as a TV reporter near the start of the film.

🎥 *Braindead* Director Peter Jackson makes a cameo appearance as the mortuary director's assistant when Lionel's mum is

being filled with embalming fluid. As other fluid gushes out of Mum, Jackson grabs the sandwich he has left beside the corpse and takes a bite.

Cannonball Run II The man who gets out of his Porsche at the starting line to chew out the driver of the monster truck (who later runs over the Porsche) is director Hal Needham.

Casino Director Martin Scorsese makes three separate cameo appearances. The first is at the casino hearing, sitting next to Mr Greene. The second is when Robert De Niro answers the door after calling back home for help to find his daughter. The third is the scene in the courtroom.

Chasing Amy The woman to whom Joey Lauren Adams is singing and with whom she is making out at the bar was actually star Jason Lee's then wife.

Chinatown Director Roman Polanski has a cameo as the hoodlum who cuts Jake's nose.

The Crow Right after Gideon's Pawn Shop blows up and the police officer and Eric are talking, the officer yells at the people looting the shop. A looter runs away with a TV set. This is actually James O'Barr, creator of *The Crow* comic series. He was on the set one day and the film-makers asked if he wanted to be in the movie.

Daredevil When young Matt Murdock stops the guy from walking into the street, that man is Stan Lee.

Dodgeball: A True Underdog Story After Peter tells Steve the Pirate that he is not a pirate, Steve gets depressed and starts walking down the Las Vegas sidewalk. A truck drives by, and one

of the passengers yells something at Steve and throws a cup. The man who throws the cup is in fact the director of *Dodgeball*, Rawson Marshall Thurber.

The Doors Director Oliver Stone can be seen briefly as one of Jim Morrison's college professors.

Erin Brockovich When Julia Roberts is in the diner, the waitress is played by the real Erin Brockovich. A close look at her name tag will reveal that her character is called Julia, in a nice mirroring of reality. The real Ed Masry is sitting directly behind Julia Roberts.

Evil Dead II In the last scene, after Ash has travelled back in time, a knight lifts his visor and shouts, "Hail he who has come from the skies to deliver us from the terrors of the Deadites." This knight is Sam Raimi, the director. The knight to his left is his brother, Ted Raimi.

The Evil Dead On the tape recording there is a sentence that sounds like "El sama ad dasa El roba da hiker don sides of ze roadsa" which means "Sam (Raimi, director) and Rob (Tapert, producer) are the hitch-hikers on the side of the road." They are the fishermen who wave at the honking car towards the beginning of the film.

Fantastic Four Fantastic Four creator (and Marvel editor-in-chief) Stan Lee has a cameo as Willy Lumpkin, the Four's mailman. To date, it's his only Marvel movie cameo based on an actual comic character.

The Fast and the Furious When the "pizza boy" is stopped by the drag racing, the driver is Rob Cohen, the film's director.

Fear and Loathing in Las Vegas In the discotheque scene where people turn to monsters, and Johnny Depp passes a seated old guy who looks very like him (bald and with hippy glasses) and who is surrounded by females, this is none other than Hunter S. Thompson himself.

Ferris Bueller's Day Off When Rooney is at the pizza parlour and he is walking up to the counter, the man standing to the right of Rooney (wearing glasses and looking at the TV) is director John Hughes.

The Fly The film's director, David Cronenberg, has a cameo in this film as the doctor who helps Ronnie give birth to her maggot baby.

Forrest Gump When Gump phones to report the break-in at the Watergate, the security guard who answers the phone says, "Security, Frank Wills." This part is played by the real guard who was on duty that night – he was the person who discovered the break-in.

The Frighteners When Frank comes out of the newspaper building, he walks into a guy with piercings and a T-shirt with the Grim Reaper on it. This is the director, Peter Jackson.

From Russia With Love On the train an old man with a walking stick passes Bond. The man is Ian Fleming, the writer of the Bond books.

Gangs of New York When Jenny is at the upper-class home disguising herself as a maid to rob it, the man (the home's owner) at the head of the table during dinner is Martin Scorsese, the director of the film.

Ghost The director Jerry Zucker always places his mother in a cameo role. In this film she's the bank clerk whom Oda Mae asks, "May I keep this pen?"

The Goonies Richard Donner, the film's director, had an uncredited cameo appearance as a police officer, seen when the kids leave the cave with the ship.

Halloween Director John Carpenter provides the voice of Annie's boyfriend, Paul, whom we hear on the phone talking to Annie.

The Hitchhiker's Guide to the Galaxy The Marvin featured in the 1981 BBC television show can be seen in several shots in the scene in the Vogon Bureaucracy. Arthur does a double take as he passes him.

Home Alone 2: Lost in New York Right before the camera shows Kevin walking up to Mr Duncan to pay for his things, there is a shot of a man and his baby. The man is really Chris Columbus (the director of the movie) with his daughter (Eleanor Columbus) who later played Susan Bones in the first two Harry Potter movies.

In the scene where Kevin is first entering the Plaza, he stops to ask a man where he might find the lobby. The man Kevin stops is Donald Trump, the real-life owner of the Plaza.

Hot Shots Part Deux Charlie Sheen's father, Martin, appears very briefly as Captain Benjamin Willard, his character from *Apocalypse Now*.

The Hulk Stan Lee, who co-created the Hulk, and Lou Ferrigno, who played him in the 1970s TV show, have cameos as a pair of security guards at the beginning of the film.

Indiana Jones and the Temple of Doom When the main characters arrive at the plane after the club scene, the man who walks them to the plane is Dan Aykroyd. He's hard to make out but you can recognise his voice easily.

Jackie Brown The voice on Jackie's answering machine in her apartment belongs to Quentin Tarantino.

Jaws The reporter on the beach is Peter Benchley who wrote the novel *Jaws* and also co-wrote the film's screenplay.

Jay and Silent Bob Strike Back The voice of the security guard we hear at the other end of the radio (when discussing the difference between a 10-07 and a 10-82) is Ben Affleck's.

JFK The real Jim Garrison plays Earl Warren, head of the Warren Commission.

Director Oliver Stone can be seen briefly in the assassination re-enactment. He plays the Secret Service agent who runs towards the back of the limousine after the fatal head-shot.

The anaesthetist who officially declared John F. Kennedy dead (Dr M.T. Jenkins) plays himself in the film. He was impressed at the level of research and detail that had gone into the preparation for that important scene. He even said the tiles on the set of Trauma Room One were the exact same shade of green that he remembered, although the scene is shown in black and white in the film.

Leon In the shot of the outside of Tony's restaurant, before the scene where we see him celebrating his birthday and being interrupted by Stansfield, someone is walking past the restaurant. That person is Luc Besson, the director of the movie.

The Living Daylights The conductor of the orchestra at the

end of the movie is the composer of the James Bond theme music, John Barry.

🎥 *The Lord of the Rings: The Fellowship of the Ring* When the Hobbits enter Bree, right after the wheel of the carriage passes in front of them, there is a man at the right who's holding a carrot and who burps. That is Peter Jackson making a cameo appearance.

A pictorial cameo: the two portraits in oval frames hanging above the fireplace in Bag End are of Peter Jackson and Fran Walsh.

🎥 *The Lord of the Rings: The Return of the King* When Gandalf is talking about the gathering of the armies of Sauron, the next shot shows the Corsairs on a ship. Walking there from right to left is Peter Jackson in a cameo as a Corsair pirate. In the extended DVD, at the start of the second disc, he is actually pierced in the chest by Legolas's arrow and dies dramatically.

🎥 *The Lost World: Jurassic Park* In the final scene, when the little girl is watching the TV news and when the TV first comes into shot you can see the reflection of four people on the couch: one of them is Steven Spielberg.

Does anyone recognise the guy who was eaten by the Tyrannosaurus Rex in San Diego? It was the screenwriter of *Jurassic Park* and *The Lost World*, David Koepp. Despite just being in there to die, his character gets a credit at the end – "Unlucky bastard".

🎥 *Love Actually* "Pat the Housekeeper", who is introduced in the first scene in 10 Downing Street, is played by the director's mother-in-law.

🎥 *The Man Who Knew Too Much* Alfred Hitchcock makes his regular cameo appearance while watching a group of street entertainers.

🎥 **Men in Black II** When J & K go to K's old house there is a family sitting on the sofa. In the centre of the three people is the movie's director, Barry Sonnenfeld. The little girl on the couch is Tommy Lee Jones's daughter, Victoria. The mother is played by associate producer Stephanie Kemp.

Towards the end, when J and K are flying in the jet-car to get away from Serleena, they neuralyse two kids in the street. The two kids are Will Smith's sons.

🎥 **Minority Report** On the subway train, the man holding the *USA Today* paper is Cameron Crowe, and the woman in the seat behind him on his left is Cameron Diaz. Because *Vanilla Sky* and *Minority Report* were shot so close together the two directors (Crowe and Spielberg) each agreed to play cameos in each other's film.

🎥 **Monty Python's Life of Brian** When Brian wakes up after spending the night with the girl he walks downstairs and finds loads of his followers in a cellar. He gets introduced to a guy with a deep Liverpool accent and a big bushy beard who says "'Ello." This man is the late George Harrison.

🎥 **Night Shift** The annoying saxophone player in the subway for whom Henry Winkler writes a cheque is Ron Howard, the director.

🎥 **North by Northwest** Alfred Hitchcock's cameo comes at the end of the opening credits – he can be found missing the bus.

🎥 **Not Another Teen Movie** The woman at the airport who talks to Janie and Jake about how they stole their speeches from *She's All That* and *Pretty in Pink* is played by Molly Ringwald, a teen-movie icon in the 1980s, who starred in *Sixteen Candles*, *Pretty in Pink* and *The Breakfast Club*.

Old School The man who shows up at the door to ask about the orgy is the director of the movie: Todd Phillips.

Panic Room When Jodie Foster phones her ex-husband's girlfriend, the voice on the phone is that of Nicole Kidman. She was originally chosen for this role but was unable to go through with it, due to a knee injury she got while making *Moulin Rouge*. She was replaced by Jodie Foster but was given this small part instead.

The sleepy neighbour whose attention they try to attract is played by Andrew Kevin Walker, the screenwriter of *Se7en*, which was also directed by David Fincher.

The Passion of the Christ The hand holding the nail as it is being driven into Christ's own hand is that of director Mel Gibson.

The People vs Larry Flynt The real Larry Flynt appears as a judge in the film.

Platoon During the last night-battle scene an NVA "Kamikaze" runs into a US command bunker that's full of GIs and blows himself up. One of those GIs is director Oliver Stone.

Police Academy The man who gets out of his car and shouts at Mahoney and Hightower after they accidentally rear-end him is director Hugh Wilson.

Poltergeist Steven Spielberg wrote and produced this film and rumour has it that he made the majority of the decisions concerning it. The hands that tear the flesh off the investigator's face in the bathroom are his.

Pretty Woman At the beginning of the movie, when Edward is driving around trying to find Beverly Hills, the bum

whom he asks for directions is actually the director of the movie, Garry Marshall.

🎥 *The Princess Bride* In the scene where the Rodent of Unusual Size is snuffling around, it's the director, Rob Reiner, who is making the snuffling noises.

🎥 *Psycho* Alfred Hitchcock makes a cameo appearance in the film during the scene when Marion Crane walks into her office. He is standing outside the office in the right-hand corner (viewer's p.o.v.).

🎥 *Rear Window* Hitchcock makes a cameo appearance, as he does in all his movies. This time it is a re-enactment of a scene from one of his other movies, *Rope*. Hitchcock here is standing in for James Stewart and the character that he played in *Rope* since in this scene Mr Stewart is busy spying.

🎥 *The Right Stuff* The barman called Fred in Pancho's Happy Bottom Riding Club is played by the real Chuck Yeager. He was on set as an adviser and was given a cameo role.

🎥 *Road Trip* Director Todd Phillips has a cameo part in the film: he is the foot fetishist who licks Beth's toes on the bus, while she is sleeping.

🎥 *RoboCop* Director Paul Verhoeven makes a cameo appearance in the film when RoboCop is arresting Leon in the disco. After Leon kicks RoboCop in the groin he falls in agony, and the camera cuts to a man who appears to be laughing madly at the camera and waving his arms. That's Paul.

🎥 *Rope* There is a cameo appearance by Alfred Hitchcock at the beginning of the film. He can be seen walking in the street.

🎥 **S.W.A.T.** Director Clark Johnson appears in the film briefly as Deke Kay's beat partner. In the credits, he's referred to as "Deke's Handsome Partner".

🎥 **Scream** When Henry Winkler is looking for the "kids" that he thinks keep knocking on his door, he opens the door of one room and surprises a cleaner. Not only is the cleaner dressed like Freddy Kreuger, but he's called Fred, and is played by Wes Craven himself.

When Sidney is going into school, and TV reporters are chasing her, there is an auburn-haired reporter who says, "People want to know, they have a right to know." That actress is actually Linda Blair, who played Regan in *The Exorcist*.

🎥 **Scream 2** At the start Sidney is watching the TV in her dorm room when Cotton is talking on a show. The interviewer he is talking to is the writer of *Scream* and *Scream 2*, Kevin Williamson.

Mathew Lillard, one of the killers in the original *Scream*, has a cameo role at the party at Delta Lambda Zeta house. He is at the back of the screen when Randy says "cocktail".

The girl that Cici talks to on the phone, just before the killer calls, is Selma Blair.

🎥 **Se7en** The dead man at the very beginning of the movie is Andrew Kevin Walker, the writer of the movie.

🎥 **Shaun of the Dead** At the end of the movie there is an obvious cameo appearance by Chris Martin of Coldplay, supporting a foundation called Zomb-Aid. However, he appears in a less obvious role earlier – he can be seen as a zombie at the pub. When Shaun and Liz come out from the cellar, he is the zombie walking from right to left in front of a phone box.

🎥 *The Shawshank Redemption* The mugshots we see attached to the parole papers of Morgan Freeman when he was younger are actually pictures of Morgan's son, Alfonso Freeman.

🎥 *The Silence of the Lambs* The bearded man who is with Chilton and the two guards who forcibly remove Clarice after her final meeting with Hannibal Lecter is played by classic horror director George A. Romero.

🎥 *Sin City* The priest to whom Marv speaks is played by Frank Miller, the creator of the *Sin City* graphic novels and co-director of the movie.

🎥 *Spider-Man* At the festival when the Green Goblin throws his grenades and the crowds react, right before they get a shot of Parker, Stan Lee (creator of *Spider-Man*) was originally supposed to pick up the little girl whom he was pushing to safety. But Mr Lee is quite old now, and after several takes he said that if the film-makers wanted him to pick her up they were going to be there all day.

🎥 *Spider-Man 2* In the scene where Peter drops his books in the college grounds and bends down to pick them up, a black bag comes by and smacks him in the face. The person carrying the bag is director Sam Raimi.

Spider-Man creator Stan Lee makes his standard cameo appearance for this film when Spider-Man and Doc Ock are fighting on the side of the building. The first shot of the street during the fight shows a woman being pushed out of the way as some debris falls; the man pushing her is Mr Lee.

The two boys on the train who return the mask to Peter are in fact Tobey Maguire's half-brothers.

"The Punisher" has a small cameo role in *Spider-Man 2*. At the end, when Mary Jane is running through the park with her wedding

dress on, Thomas Jane, who played The Punisher in the 2004 film of the same name, can be seen glancing at her while she runs past. He is not in any kind of costume, but it is him nonetheless.

Star Wars: Episode II – Attack of the Clones When Anakin is walking around the bar in Coruscant, looking for the changeling, he passes Ahmed Best, who plays the voice of Jar Jar Binks. Anthony Daniels, who plays C-3PO, and Katie Lucas (George Lucas's daughter) are also visible.

Star Wars: Episode III – Revenge of the Sith George Lucas makes a cameo appearance during the opera scene. He is the blue-faced being, named Baron Papanoida, outside Palpatine's box. This is Lucas's first and only appearance in any of the *Star Wars* films. Reportedly, Lucas also provides the sound of General Grievous's coughing.

Swingers The guy sitting at the $100 table is Vince Vaughn's father and the old lady who wins at blackjack on the $5 table is Jon Favreau's grandmother.

Taxi Driver Director Martin Scorsese makes an extended cameo appearance – he's the passenger who sits in Travis's cab talking to him about how he's going to kill his wife for cheating on him with a black man. He's credited as "Man watching silhouette".

Terminator 2: Judgment Day The screams that the T-1000 makes as it dies are provided by director James Cameron.

The Terminator At the beginning of the film, Sarah Connor listens to an answering-machine recording of her boyfriend breaking off a date. The voice on the answering machine belongs to James Cameron.

📽 *Titanic*　In the scene where Jack is sketching the picture of Rose, the hands in the close-up shots are actually those of James Cameron himself, drawing with the charcoal.

📽 *True Lies*　The helicopter pilot who has the line "She's got her head in his lap – yahoo!" is voiced by James Cameron.

📽 *Vanilla Sky*　At Tom Cruise's birthday party, you can see Steven Spielberg wearing a "Pre-crime" baseball cap from *Minority Report*, also starring Tom Cruise and filmed shortly afterwards.

📽 *Vertigo*　Alfred Hitchcock appears eleven minutes into the film, walking past the building that James Stewart is about to enter.

📽 *War of the Worlds* (2005)　Gene Barry and Ann Robinson, stars of the 1953 version of this movie, make a small cameo appearance in this version as Mary Ann's parents. You can see them at the end when the whole family is reunited.

📽 *When Harry Met Sally*　In the famous faked-orgasm scene, the woman who says, "I'll have what she's having" is played by Rob Reiner's mother.

📽 *The Whole Nine Yards*　During their walk, when Jimmy and Oz stop at a flower stall, the three girls who run between them shouting, "I'm gonna kill you!" are Bruce Willis's three daughters.

📽 *X-Men*　Stan Lee, creator of the *X-Men* comics, has a cameo role in the beach scene as a hot-dog vendor.

📽 *X-Men 2*　Director Bryan Singer plays the guard who initially rolls Professor Xavier into the guardroom in the glass wheelchair before passing him on to the other guards.

📽 *Young Guns* When the Regulators are making their escape from the house at the end, the extra shot right after Charlie (Casey Siemaszko) busts out of the house shows a young Tom Cruise. He was on set visiting his friend Emilio Estevez and got into make-up (including huge sideburns) and appeared on screen.

📽 *Young Guns 2* When the prisoners escape from the pit that Doc and Chavez have been held in, there's a prisoner who gets out, grabs a gun and tries to shoot one of the guards, only to be shot in the chest and perform a backflip into the pit once more. It's Jon Bon Jovi, who did the soundtrack for the movie.

CROSS-REFERENCES

Films often make subtle (or not so subtle) references to other films – either to other work that the director's been involved with, or often to just one aspect of another movie that someone thought was cool. Trouble is, if Film A refers to Film B, and you've not seen Film B, then the reference can often go right over your head. Not any more ...

🎥 *1941* At one point John Belushi lands his plane on a highway in the desert and pulls up to a petrol station to refuel. The petrol station is the same one used in Steven Spielberg's first movie, *Duel*, and the actress who plays the woman running it was also seen in that movie.

🎥 *The Abyss* The fictional company that owns and operates the undersea drilling rig is called Benthic Petroleum. In *Terminator 2* (also directed by James Cameron), after the escape from the mental hospital our heroes hide out at a filling station. The pumps at this station also feature the Benthic Petroleum logo.

🎥 *Alien Resurrection* When Johner, Christie and Call are watching the home-shopping channel, one of the items on sale is a pearl-handled, semi-automatic pistol, the very same one wielded by Vasquez in the previous instalment, *Aliens*.

🎥 *Alien vs Predator* When Weyland is in his office near the beginning of the movie, he's playing with his pen. He starts tapping it on his desk between his fingers, alternating which two fingers he taps between. This is what Bishop does in *Aliens* (albeit with a knife), with his hand on top of Hudson's; maybe it was programmed into Bishop's subconscious.

The opening shot of the film is of a Weyland Satellite. However, the first silhouette is actually that of the Alien Queen from *Aliens*. The satellite is also constructed and filmed to resemble the front of the *Sulaco*, also from *Aliens*.

Animal House At the end of the film when viewers are brought up to date on each character, they are told that Lieutenant Neidermayer was shot by his own men in Vietnam. In the film *Twilight Zone: The Movie*, during the segment directed by John Landis, one of the American soldiers in Vietnam says, "I told you guys we shouldn't have shot Lieutenant Neidermayer."

Army of Darkness The magic words that Ash says to safely pick up the book of the dead are "Klaatu verata nikto". This phrase originated from *The Day the Earth Stood Still*, where a slightly modified version was used ("Klaatu barada nikto"). Those three words are also the names of three aliens on Jabba the Hutt's barge in *Return of the Jedi*.

Back to the Future The amplifier that Michael J. Fox blows up at the beginning is described on its label as a CRM-114. This is a reference to *Dr Strangelove*, in which the B-52 crew receives its orders over a CRM-114 transponder. It is also the serial number of the Jupiter explorer craft in *2001: A Space Odyssey* (1968), another Stanley Kubrick film.

Beetlejuice Jack Skellington, the main character in Tim Burton's later film *The Nightmare Before Christmas*, can be seen on top of Beetlejuice's hat when he comes up through the table at the end of the film.

Big Fish The banjo player in Spectre (Billy Redden) is playing "Duelling Banjos", the same song he played in *Deliverance* as a boy. These are his only two movie appearances.

The spiral hill in *The Nightmare Before Christmas* reappears here on a tie that the young Edward Bloom wears. It was one of several options presented to Tim Burton and, perhaps unsurprisingly, it appealed to him the most.

Blade Runner In the scene where Deckard (Harrison Ford) and the other policeman take off in a police spinner, there is a shot of the inside of the vehicle showing a computer screen with the flashing word "Purge" on it. The screen was originally used in *Alien* when Ripley took off in the shuttle to escape from the *Nostromo*.

The Blair Witch Project In the scene in the supermarket near the beginning of the film, someone in the background says, "You're Rick Derris?" This line comes from *Clerks*.

Boogie Nights Don Cheadle talks to a customer about the TK421 stereo system. "TK421" came up in *Star Wars*, as the call sign of a storm trooper when Han and Luke beat up the troopers and put on their uniforms.

The Bourne Supremacy The photo of Nicky in her confidential file is actually a promotional shot of Julia Stiles taken in 1999 for the teen comedy *10 Things I Hate About You*.

Charlie and the Chocolate Factory Charlie's father works in the Smilex Toothpaste factory. Smilex was the name of the deadly poison gas used by The Joker to kill people in *Batman*.

Charlie's Angels When Drew Barrymore is almost naked and knocks on the window of a house after her escape and her tumble down a hill, it is the same house that she lived in in the movie *E.T. The Extra-Terrestrial*. An *E.T.* poster is visible in the room.

🎬 *Chasing Amy* When Holden and Alyssa are talking in the Meow Mix club, they mention the Quick Stop and one event that took place there in *Clerks* (other Kevin Smith movie). They also talk about the girl who drowned in the YMCA pool, which is also mentioned in *Clerks* and *Mallrats*.

During the lesbian-bar scene, they are all around the table. The lights behind them glow eerily like portholes. They re-enact the scene from *Jaws* where the characters compare injuries, only with sex stories. Even putting the leg on the table comes from *Jaws*. This scene was originally meant to be in *Mallrats* but was rejected by the studio.

🎬 *A Clockwork Orange* In the scene where Alex approaches the two girls at the record stand the original score for *2001: A Space Odyssey*, also directed by Stanley Kubrick, is visible.

🎬 *Die Hard: With A Vengeance* When John McClane (Bruce Willis) is asked what he has done during his suspension from the police force he says, "Smoking cigarettes and watching *Captain Kangaroo*." This is a line from the song "Flowers on the Wall", which plays on the radio in *Pulp Fiction*, and Willis's character in that film sings along to it just before he runs over Marcellus Wallace. *Pulp Fiction* was released between *Die Hard 2* and *Die Hard: With A Vengeance*.

🎬 *Dirty Harry* After Harry Callahan manages to foil the bank robbery at the start of the film, he walks over to the one surviving bank robber. As he does so, he moves past a cinema that is showing *Play Misty for Me*, which Clint Eastwood directed and starred in.

🎬 *Dog Soldiers* After Sarge and Cooper break through the floor into the kitchen, Sarge retrieves his watch from the

dismembered corpse of Witherspoon (nickname "Spoon"). Cooper asks where Spoon is and the Sarge replies, "There is no Spoon." Seems to be that character's name was picked solely for its reference to *The Matrix*.

Dogma Silent Bob's only line – "No ticket" – is a reference to *Indiana Jones and the Last Crusade*. Indy says the same thing when he throws the Nazi off the plane.

E.T. The Extra-Terrestrial Inside E.T.'s spaceship are several plant specimens. One of the plants is a triffid – from the movie *Day of the Triffids*.

Evil Dead II There is a Freddy Krueger glove visible in the basement just before Ash goes into the pipe section to retrieve the pages of the *Necronomicon*.

The Evil Dead In the scene where Ash is in the cellar, a poster for Wes Craven's film *The Hills Have Eyes* is hanging on the wall. Wes Craven then repaid the compliment in *Nightmare on Elm Street* by having *Evil Dead* playing on the television in Nancy's room when she is trying not to sleep.

Ferris Bueller's Day Off The number plates seen on various cars are abbreviations of titles of films by director John Hughes. Katie's is VCTN (*National Lampoon's Vacation*), Jeannie's is TBC (*The Breakfast Club*), Tom's is MMOM (*Mr Mom*), and Rooney's is 4FBDO (*Ferris Bueller's Day Off*). The one plate not relating to other films is still relevant – Cameron's Ferrari's plate, seen after Sloane is picked up, reads NRVOUS.

Fight Club When the Narrator turns himself in to the police and explains the goal of Project Mayhem (near the end of the film), he is interrogated by four detectives. The three who then try

to kill him are named in the credits as Detectives Andrew, Kevin and Walker. Andrew Kevin Walker penned the script for *Se7en*, which David Fincher also directed. He also did some work on this script.

When Edward Norton falls against a brown estate car during the first fight with Brad Pitt, there is a CRS sticker on the windscreen. This is the same car seen in *The Game*, which Michael Douglas hides in while James Rebhorn drives him to CRS headquarters. Both films are directed by David Fincher.

🎥 **Finding Nemo** The great white shark in the rehab group is named Bruce. This is one of several Monty Python references, and it's also the same name that Steven Spielberg gave the mechanical shark in *Jaws*.

🎥 **From Dusk Till Dawn** The conversation between Kate and Seth while they're waiting for the final vampire attack ("Use 'em on the first couple of these parasites that try to bite you") is taken almost word for word from the original John Carpenter version of *Assault on Precinct 13*. Scott Fuller is wearing a T-shirt with "Precinct 13" on it.

🎥 **Galaxy Quest** The Thermians say that they are from the Klaatu Nebula. Klaatu is the name of the alien (played by Michael Rennie) who visits Earth in *The Day the Earth Stood Still*.

The number seen on the spaceship, the NSEA *Protector*, is NTE 3120. NTE stands for "Not The Enterprise".

🎥 **Gladiator** When Maximus talks to Lucius about the two horses on his armour, the names he gives them (Argento and Scarto) can be translated as "Silver" and "Trigger", the names of the horses belonging to The Lone Ranger and Roy Rogers respectively.

Godzilla (1998) The mayor is named Ebert and his assistant is named Gene. These two were parodies of two well-known movie critics: the late Gene Siskel (who died in 1999 from complications from brain surgery) and Roger Ebert. They gave bad reviews for *Stargate* and *Independence Day* which were also made by Roland Emmerich and Dean Devlin, so this is also their way of getting back at them. The actors who play them also look similar to Siskel and Ebert.

Gremlins At the beginning of the film, when Billy is late for work, two films are playing at the cinema: *A Boy's Life* and *Watch the Skies*. The former was the original title for *E.T.* and the latter was the original title for *Close Encounters of the Third Kind*. Both films were directed by executive producer Steven Spielberg.

A History of Violence Mick's story about how his girlfriend once stabbed him in the shoulder with a fork relates to an accident on the set of David Cronenberg's 1975 film *Shivers*, when Lynn Lowry stabbed Cronenberg in the shoulder with a fork. David Cronenberg's own shoulder was used as the one which Nurse Forsythe stabs with a fork – a pad was placed under Cronenberg's shirt for Lowry to stab, but unfortunately she missed the pad, making contact with his real shoulder instead.

The Incredibles When Mr Incredible meets Buddy he tries to recall his name and initially calls him Brody. Jason Lee, who provides the voice of Buddy, shot to stardom in *Mallrats* playing Brodie, a character who was also obsessed with superheroes.

Indiana Jones and the Temple of Doom The movie opens with a scene in a nightclub. After the fight is over, and Indy and Willie make their escape, the *Star Wars*-related name of the club is seen as they drive away – Club Obi Wan. George Lucas wrote the story for this film.

Jurassic Park Alan Grant (played by Sam Neill) digs up dinosaurs in Montana. When Sam Neill's character (Vasily) dies in *The Hunt for Red October*, released three years earlier, his last words are "I would liked to have seen Montana."

Kill Bill: Volume 1 The yellow tracksuit that Uma Thurman wears during the tea-house scene is a replica of the one worn by Bruce Lee in the movie *Game of Death*.

The sword used by Uma Thurman in this film is the same one that Bruce Willis used to escape in *Pulp Fiction*.

Kill Bill: Volume 2 After Daryl Hannah has her eye plucked out, she falls onto her back on the floor and begins screaming and flailing her arms and legs much like her character (Pris) did in *Blade Runner* after she was shot.

The Majestic When Jim Carrey leaves the bar that he was drinking in with the monkey, the sign behind him reads Coco Bongo. The Coco Bongo Club is the new club in another Jim Carrey movie, *The Mask*.

Mallrats LaFours, the security guard who wears the white straw cap, is a reference to LaFours in *Butch Cassidy and the Sundance Kid*, who also always wore a white straw cap.

When they're in the dirt mall, the cap that TS tries on has *Clerks* on it, the title of the previous film by Kevin Smith.

Note the *Jaws* reference – not the obvious marriage-scene link: the main characters are called T.S. Quint and Brodie Bruce, a reference to Quint and Brody from *Jaws*. The nickname for the shark on set was "Bruce".

Mars Attacks! In one of the scenes inside the Martians' UFO the fat clown who is killed by The Penguin in *Batman Returns*

(also directed by Tim Burton) can be seen inside one of the glass spheres.

Maverick The bank robber is played by Danny Glover – he and Mel Gibson seem to recognise each other from somewhere, but neither of them can place where. Both actors starred in the *Lethal Weapon* films, also directed by Richard Donner. On the soundtrack are a few notes from the *Lethal Weapon* theme music as well.

Mission: Impossible 2 While talking to Ethan Hunt (Tom Cruise), Anthony Hopkins asks him if he would like a cappuccino. In the previous *Mission Impossible* film, Ethan asks Jim Phelps (Jon Voight) if they can get a cappuccino machine.

Monsters, Inc. Mike and Celia have dinner at an eatery called Harryhausen's. This is a tip of the hat to Ray Harryhausen, the great stop-motion animator.

Mr and Mrs Smith A subtle clue that Brad Pitt is a secret agent/spy: he drinks vodka martinis with two olives – shaken, not stirred – just like that other famous spy, James Bond.

When John and Jane are questioning their former apparent target near the end of the film, the guy's shirt sports the logo from another Brad Pitt film, *Fight Club*.

The Mummy Returns The pygmies fall into the river after they blow up the bridge. As the right-hand end of the structure falls into the ravine, one end is glowing from the blast and one of the pygmies climbs on top of it and rides it down, hand waving, in exactly the same way that Major Kong rides the nuclear bomb at the end of *Dr Strangelove*.

Mystery Men The Blue Raja (played by Hank Azaria) says, when Captain Amazing has finished beating up the Red Eyes,

something like: "With the punching and the hurting." This is a direct reference to *The Simpsons*, where Professor Frink (one of many voices performed by Hank Azaria) talks just like that.

🎥 *A Nightmare on Elm Street* Nancy tries to stay awake so she watches *The Evil Dead* on TV. This was done by Wes Craven in recognition of Sam Raimi placing a *The Hills Have Eyes* poster in *The Evil Dead*.

🎥 *Ocean's Twelve* When Bruce Willis is in Tess's hotel room, thinking that she's Julia Roberts, Linus, referring to Julia Roberts's Oscar, says to him, "We're looking to come off this pregnancy thing strong. You know, that little statue on the mantel starts smirking at you after a while, know what I mean?" Bruce says no, he doesn't. Both Julia Roberts, whom he refers to, and Matt Damon, who plays Linus, have been awarded Oscars, while Bruce Willis has not.

🎥 *Pirates of the Caribbean: The Curse of the Black Pearl* As Elizabeth falls into the sea, Jack is talking to two military guards, obviously just finishing a fascinating story with the phrase ". . . And they made me their chief." This is one of the few lines spoken by the permanently drunk and incoherent Rowley Birkin QC, Johnny Depp's favourite character from *The Fast Show*. It's also referred to in one of the deleted scenes on the DVD where Jack and the pirates are improvising about the French ("They invented mayonnaise") – his last line in the clip is "I'll get me coat."

🎥 *Predator 2* In the Predator's trophy collection on his spaceship a skull from the creature in the *Alien* movies takes pride of place.

🎥 *The Princess Bride* Mark Knopfler, who composed the music for *The Princess Bride*, only agreed to do so if Rob Reiner

would include the baseball cap he wore in the film *Spinal Tap*. The director placed the cap in the boy's bedroom, beside the bed.

Pulp Fiction In *Reservoir Dogs*, Nice Guy Eddie arranges for Mr Orange (Tim Roth, all shot to pieces) to be treated by a nurse he knows named Bonnie. In *Pulp Fiction*, Jimmy's wife is a nurse named Bonnie.

When Vince and Mia are going into Jackrabbit Slim's, Vince has a good look around. He notices a toy-car race going on (the sort where the cars are on a track). The colours of the tracks are blue, pink, white, orange, yellow and brown – the colour-coded aliases that the thieves in *Reservoir Dogs* (Tarantino's debut hit) were assigned (with yellow representing Mr Blond, obviously).

Raiders of the Lost Ark In the Well of Souls, there are hieroglyphics of *Star Wars* characters C-3PO and R2-D2 on the wall.

The registration code of the plane on which Indy escapes at the start is OB-CPO. George Lucas was the writer of this film and of *Star Wars*.

Reservoir Dogs Mr Blond's parole officer is called Seymour Scagnetti. The cop in *Natural Born Killers* is also called Scagnetti. Mr White mentions that he used to hang out with a woman called Alabama, which is the name of the lead female character in *True Romance*.

The Rules of Attraction When Sean Bateman answers the payphone call from Paul, he asks if it's Patrick calling. Patrick Bateman was a character from *American Psycho*, played by Christian Bale, which was made by the same production company. Also, Patrick Bateman was Sean's brother in the novel. Christian Bale turned down an offer to appear as Patrick in this film – Casper Van

Dien shot some scenes as Patrick instead, but these were eventually cut.

🎥 **Scream** In the beginning, when Casey's parents hear her choking on the phone, Casey's dad says, "Listen, I want you to drive to the MacKenzies' house and call the police." At the end of the movie *Halloween*, Laurie Strode also tells the two little kids whom she's babysitting to walk over to the MacKenzies' house to call the police.

🎥 **Serenity** The ID number (C57D) of the ship seen crashed on the planet Miranda is the same as the ID number of the ship in *Forbidden Planet*.

🎥 **Shark Tale** When all the sharks are sitting around the table Lenny coughs up several items, including a licence plate (007 981). This is the same number on the licence plates from both *Jaws* and *Deep Blue Sea*.

🎥 **Shaun of the Dead** When he's at work, talking to the youngsters, Shaun mentions that "Ash" is also sick and can't come to work. This is a nod to the classic *Evil Dead* trilogy in which Bruce Campbell plays Ash, also a sales assistant.

As the gang shuffle towards the pub, in one or two brief shots of the zombie mob one of the zombies is dressed exactly like the character Tyres (a bike messenger) from *Spaced* (also directed by Edgar Wright and starring Simon Pegg), and in fact is played by the same actor, Michael Smiley. There is also some bright-blue and yellow clothing around.

🎥 **Sky Captain and the World of Tomorrow** On the entrance door of Dr Walter Jenning's laboratory is written "Suite 1138", a reference to *THX 1138* (1971), directed by George Lucas.

🎥 *Swingers* Trent's licence plate reads "THX1138", another reference to George Lucas's *THX 1138* (1971).

🎥 *Trading Places* Dan Aykroyd's prison number is given as 7474505B. This is the same prison number that John Belushi has in *The Blues Brothers*, which was also directed by John Landis and also starred Dan Aykroyd.

🎬 FAMOUS SCENES

TAKE 09

There are certain scenes in the movies that everyone knows and loves, but which people don't always know the full story behind. Time to put that right ...

🎥 **Caddyshack** The famous scene that starts when Ty Webb's golf ball crashes into Carl Spackler's ramshackle house was not in the script at first. It was added by Harold Ramis, the director, when he realised that Chevy Chase and Bill Murray, the two major stars of the film, did not actually have a scene together. The two actors and Ramis met up for lunch and wrote the scene jointly. It doesn't actually have anything to do with the plot, but it is widely regarded as the funniest scene in the movie.

🎥 **Casino** The "head in the vice" scene was created by Martin Scorsese as a sacrifice, specifically to distract the attention of censors away from other scenes of violence that wouldn't seem so bad by comparison. When, surprisingly, the MPAA made no objection to the vice scene, he left it in, albeit in a slightly edited form.

🎥 **The Dead Zone** During the "burning bedroom" sequence, Christopher Walken's face seems to be drenched in sweat. The liquid was actually a flame-retardant chemical that had been sprayed onto his skin to protect him from the fire. The appearance of sweat, which hadn't been planned, ended up looking suitably dramatic on film.

🎥 **The Fifth Element** The explosion in the Fhloston main hall was the largest indoor explosion ever filmed. The resulting fire almost got out of control.

🎥 **The Godfather: Part II** At Michael's hearing, very few of

the senators, judges, etc. are actually professional actors. They are friends, acquaintances and family of various members of the cast and crew.

🎥 *The Gold Rush* In the famous scene where Chaplin eats a shoe, the shoe was made of licorice. Chaplin repeated the scene so many times that he had to be hospitalised for hyperglycaemia.

🎥 *Kill Bill: Volume 1* The Bride kills fifty-seven people in the House of Blue Leaves, not eighty-eight despite the gang being called the "Crazy 88s".

🎥 *Lolita (1997)* In all the scenes where Jeremy Irons and Dominique Swain had physical contact, Jeremy Irons had to have a pillow on his lap because Swain was only fourteen at the time of filming.

🎥 *Midnight Cowboy* The most famous line in this film is ad libbed. Apparently a tough New York cabbie broke through and drove across one shot, nearly running down Jon Voight (playing Joe Buck) and Dustin Hoffman (playing Enrico Salvatore "Ratso" Rizzo). Voight's expression is visibly startled. Hoffman, still in character, slams a hand on the cab's hood and shouts at the cabbie, "Hey, I'm walkin' here! I'm walkin' here!"

🎥 *Ocean's Eleven* The order in which people left the fountain was completely improvised – Steven Soderbergh just told the actors to leave in whatever order they felt was right.

🎥 *The Player* The famous opening tracking shot is eight minutes long, and includes people talking about famous long tracking shots in other films. The scene took a day to rehearse and the actual filming took half a day. The film-makers did fifteen different takes, with five of those being considered good enough to

use in the film – in the end the third one was used. The entire sequence was unscripted, with all the dialogue improvised.

Raging Bull During the argument between Robert De Niro and Joe Pesci, De Niro asks, "Did you fuck my wife?" Director Martin Scorsese didn't think that Pesci's reaction was strong enough, so without Pesci's knowledge he asked De Niro to say instead, "Did you fuck your mother?" – which got the desired reaction. Martin Scorsese also did not tell Joe Pesci that the script called for him to be attacked, so that too came as a surprise.

Starship Troopers After a dare by star Dina Meyer, one take of the mixed-sex shower scene was shot with Paul Verhoeven (director) and Jost Vacano (cinematographer) appearing in the nude as well.

The Untouchables The gunfight between Ness's men and Capone's gang in the train station is a homage to the sequence on the Odessa Steps in *Battleship Potemkin* (1925). One plot strand of that film concerns a naval crew that mutinies, which explains why there are many sailors in this scene. The baby carriage rolling down the steps also features in *Battleship Potemkin*.

HOW DID THEY DO THAT?

No matter how caught up you are in a film, once in a while you're bound to wonder just how the film-makers got that head to explode, or that sound effect just right. Wonder no more ...

🎥 **2001: A Space Odyssey** Many of the scenes of galaxies expanding as the astronaut Dave is passing them were achieved simply by paint being funnelled down a tube and pouring out into a glass container full of water, with a camera positioned beneath to capture the effect.

In the "star gate" sequence at the end of the film, the shots that look like coloured landscapes actually come from footage left over from *Dr Strangelove* that was artificially colourised for the purpose.

The leopard lying on a dead zebra was actually lying on a dead horse, painted to look like a zebra. The big cat wasn't too happy with that scene.

🎥 **28 Days Later** To get daylight shots of the deserted streets of London, filming took place on summer weekdays in the relatively early hours of the morning just after sunrise. Crew members had to politely ask the few people around at that time of day to stay out of shot, giving the film-makers only a few minutes of shooting at a time.

🎥 **61*** For his role as Whitey Ford right-handed Anthony Michael Hall simply wore his uniform number and logo backwards rather than having to learn to pitch left-handed. The image was then flipped.

🎥 **The Abyss** In the final shot – when the alien ship rises to the surface – the season is meant to be spring or summer. However,

this scene was filmed around the start of winter, so to avoid the obvious give-away of the actors breathing out visible water vapour they kept ice cubes in their mouths, chilling their breath enough to stop that happening.

The dead sailor whose body turns out to have a live crab living in it is played by Mike Cameron, director James Cameron's younger brother. The scene had to be shot several times to get it right, forcing Mike to hold a succession of live crabs in his mouth until the cry for "Action!" allowed him to release them. At one point he had to crush one with his teeth, as it was giving him quite a bit of grief.

Alien For the wide shots where we see Kane and Co. walking around outside the *Nostromo*, Ridley Scott used children (two of which were his own) in special child-sized spacesuits so that the sets would appear bigger in comparison to the people on screen. He used the same tactic again when the *Nostromo* crew members discover the fossilised space jockey on the alien ship.

To get the right effect for the contents of Ash's head (Ash is the android played by Ian Holm) its interior was filled with spaghetti, fish roe and onion rings.

To give the impression of the *Nostromo*'s engines firing out plasma, powerful lights were placed around cascading water and then the effect was filmed from below.

The flight deck of the ship was designed so that the cast's consoles would be linked. Thus something happening at one console would cause a reaction at another. Ridley Scott did this to make the actors' performances more realistic: rather than making random guess-work movements, they would be constantly reacting to what other people did.

When Yaphet Kotto gets killed by the alien, the effect of damage to his head was created by using a watermelon, a fruit that on further examination does not closely resemble a human head.

When Kane is in the egg pit on the alien ship and shines his light on one of the eggs, the shape we see moving inside it is in fact the hands of director Ridley Scott clad in rubber gloves.

🎥 *Alien Resurrection* The basketball shot that Sigourney Weaver makes without looking is 100% genuine. She had a lot of practice and was determined to do it, despite the director wanting just to drop the ball in from above. She managed it on the first take, stunning other members of the cast and crew – Ron Perlman (just behind her) turns around and starts to break character, but the shot is quickly cut. The ball leaves the frame briefly, and some people wanted to use CGI to make it visible the whole time, but the film-makers eventually decided to leave the scene unaltered. The DVD includes a longer version of the shot that shows the cast reacting to Ms Weaver's expertise.

🎥 *Aliens* Vasquez and Drake use "smart guns", which are mounted on their bodies. These mounts are adapted Steadicams.

To make the aliens' blood smoke and burn, the SFX department came up with the idea of placing two separate chemicals side by side in bags inside the alien puppets, on top of the explosives. Whenever an alien was shot the two chemicals combined, creating a nasty, acidic burning effect.

🎥 *American Graffiti* Unusually enough, this film was shot in sequence so that as filming progressed and the actors got more tired their characters would look suitably exhausted as the night wore on.

🎥 *American Pie* To achieve realistic-looking semen in the cup from which Stifler drinks, the film-makers just added egg white to the beer.

📽 *Arachnophobia* Since spiders really aren't trainable, the film-makers blew on them with hairdryers to get them to move correctly.

To get the right visual effect of spiders being crushed underfoot, the effects team used single-portion packets of mustard. The sound – crisps being crushed – was added later.

📽 *Army of Darkness* To give the visual impression of the chainsaw running, a tube was run up Bruce Campbell's right trouser leg, under his shirt, then into the chainsaw itself. Tobacco smoke was then pumped up the tube.

📽 *The Aviator* Director Martin Scorsese intentionally designed each time period in the film to resemble closely films made during the periods depicted. This was achieved mainly through the use of digital effects in post-production. Cinecolor and two-strip Technicolor were the primary colour methods recreated – a prime example occurs during the scene when Howard Hughes meets Errol Flynn in the club. A plate of carefully positioned peas is served on a plate to Howard Hughes, and they're more blue than green, exactly the colour that they'd have been in the two-strip Technicolor process. Cate Blanchett used three different red wigs in order to match the colour techniques. As historical time passes, the film colour gets more realistic and closer to modern quality.

📽 *Backdraft* To give an ultra-realistic impression to the audience of what a real fire is like, a cameraman was given a hand-held camera and put into a fireproof suit. He then walked right through the flames.

📽 *The Big Lebowski* It turned out to be impossible to get Walter's bag of dirty underwear to follow the right arc when it was thrown out of the window of The Dude's moving car. So the shot

was eventually filmed by having a crew member throw the bag towards the car while it was driven backwards. The footage was then played in reverse.

The Birds According to star Rod Taylor, the seagulls were fed a mixture of wheat and whiskey, the only way they could be "persuaded" to stand around for long periods.

Black Sunday Most of the climactic scene where the blimp descends into the stadium was filmed the day before an actual sports match in order to avoid setting off a real panic. At least some parts of the scene were filmed afterwards, such as the airship's nose edging onto the field – only the blimp's front portion, which was then fixed to a crane, was constructed to get this effect.

Butch Cassidy and The Sundance Kid The famous river jump was filmed at 20th Century Fox's Century Ranch, near Malibu in California. Paul Newman and Robert Redford's stuntmen really jumped off a construction crane, which was concealed by a matte painting of the cliffs, near Century Lake. Newman and Redford did make a jump themselves, in Colorado, but only landed a few feet down – on a mattress.

Carrie In the final scene, when Sue puts the flowers on Carrie's grave the hand that emerges from the ground is actually Sissy Spacek's. Sissy was buried in a box underneath the ground. She refused to use a stunt double.

In the penultimate scene, to give viewers a sense of unease the shot was filmed with Sue walking backwards. Then the film was run backwards and more slowly to produce a surreal effect. An unfortunate consequence of this device is that in the background a car drives across an intersection in reverse.

🎥 **Casablanca** Because the film was shot during the Second World War security concerns prevented the film-makers from filming at night at an airport. Instead, they used a sound stage with a small cardboard aeroplane in the background, forcing perspective by having short people move around the plane, giving the impression that the aircraft was full-size.

🎥 **Chinatown** To get the right effect for slicing Jack Nicholson's nose, a particular prop knife was used. It had a special blade that was only hinged in one direction so that if it was used the wrong way it would really have cut Nicholson – who was nervous (for obvious reasons) during the filming of the scene concerned. The people involved got so bored subsequently of explaining how the trick was done that they found it was easier just to claim that Jack Nicholson's nose was actually slashed on camera.

🎥 **Citizen Kane** The audience that watches Kane give his speech is actually a still photo. To give the impression of movement, hundreds of tiny pinpricks were made in the photo and lights were moved around behind it.

🎥 **Clerks** When the Chewlie's Gum rep throws a "smoker's lung" onto the counter, it's actually a calf's liver.

🎥 **A Clockwork Orange** To get the effect of Alex's suicide attempt from his own point of view, a camera was put into a custom-built plastic box, then thrown off a building. This had to be done six times until it eventually landed pointing downwards. Apart from breaking the camera lens, the body of the camera was undamaged – Stanley Kubrick stated how impressed he was at its sturdiness. (It was a Newman Sinclair camera.)

🎥 **The Colour of Money** Tom Cruise genuinely performed all his own trick pool shots for this film – except for one where he had

to make the cue ball jump over two balls to sink another one. Martin Scorsese said that he could have let Cruise learn the shot but that it would have taken up two extra days for practice, costing thousands of dollars extra in production delays. Instead, the shot was actually performed by professional pool-player Michael Sigel.

🎥 *The Colour Purple* The baby that Celie delivers at the beginning of the film is actually a rubber doll. The film-makers covered it in dry ice in order to make it steam.

🎥 *The Crow* After Brandon Lee's unfortunate death while filming, some scenes had to be completed without him. When his character first comes back to his apartment after digging himself out of his grave, the film-makers used existing footage of Lee walking down a rain-soaked alley and composited it into the shot of him walking through the door, digitally adding rain to the door frame so that the water on him would make sense to viewers. After he smashes the mirror and puts his make-up on, a double is doing the actions, with computer effects used to fit Lee's face to the shattered mirror. The shot of him falling out of the window actually uses a body double with Lee's face digitally edited onto him. As he walks towards the window with the crow on his shoulder, that too was a double, with Lee's face superimposed whenever the lightning illuminates him. Finally, when Sarah goes to the apartment a stand-in is used for that whole scene – we never see Draven's face.

🎥 *Cube* Only one set was used for filming – fourteen feet on each side. It was made to look like many different cubic rooms by using different-coloured panels.

🎥 *Dark City* In the scene where the two buildings are Tuned together to crush Murdoch, the effect was achieved without CGI or

other high-tech trickery. The director actually created two giant buildings on wheels and rolled them together.

🎥 **Day of the Dead** Real pig guts were used for the scene where Joe Pilato (Rhodes) is ripped in half. The guts were accidentally left out of the freezer over the weekend and so were rotten when they were used. The stench was so bad that everybody ran off the set once they had finished filming.

🎥 **The Dead Zone** To make Christopher Walken's twitches seem more involuntary, at Walken's own suggestion director David Cronenberg fired a .357 Magnum loaded with blanks just off camera.

🎥 **The Deer Hunter** For some of the Russian Roulette scenes, at Robert De Niro's suggestion a live round was actually put into the gun's cylinder to heighten the actors' tension. It was, of course, checked to make sure that the bullet was not in the chamber that was going to be fired. But the mere knowledge that it was there boosted their stress levels considerably.

🎥 **Die Hard** For the shot where Hans Gruber falls from the top of the building, Alan Rickman was dropped by a stuntman from a twenty-foot-high model onto an air bag. To get the right reaction, the stuntman dropped Rickman on the count of two instead of three.

🎥 **Dune** The tendons on the worm when it gets hooked by Paul are made from condoms.

🎥 **Equilibrium** Despite the complicated stunts, unusually for an action movie no wires at all were used. Conventional methods were used to defy gravity, such as using a trampoline to achieve the backflip off the motorbike.

🎥 *The Evil Dead* The noise for the pencil being stabbed into Linda's ankle was made by stabbing a pencil into an apple, and then tearing the apple apart with it.

To get the point of view of a demon gliding along the ground, a camera was mounted on a length of wood while Sam Raimi and Bruce Campbell ran along holding either side.

Creamed corn dyed green was used to create convincing zombie guts.

🎥 *The Exorcist* The scream of the demon being thrown out of Linda Blair was actually created by recording squealing pigs being driven to slaughter.

The green "vomit" that Linda Blair pukes up was actually green pea soup.

🎥 *Fear and Loathing in Las Vegas* For the drug scenes, Johnny Depp snorted lactose (powdered milk).

🎥 *Ferris Bueller's Day Off* Charlie Sheen (the guy in the police station) stayed awake for two days so that he could get the right drugged-out look for the scene.

🎥 *For Your Eyes Only* Close-up shots of Carole Bouquet and Roger Moore while underwater were filmed on dry land in a studio, using a powerful fan to move their hair as if they were floating. Bubbles were then superimposed and the film was played in slow motion. The shots had to be faked because Carole Bouquet had sinus trouble, making it impossible for her to dive or stay underwater for any length of time.

🎥 *Full Metal Jacket* The Vietnam scenes were shot in England. Kubrick had full-grown palm trees planted for various exterior location shots.

🎥 **Ghostbusters** The gunk used as marshmallow at the end was actually shaving cream. More than fifty gallons were deposited on William Atherton, almost knocking him to the ground.

🎥 **The Godfather** The horse's head that was cut off and placed in Woltz's bed was real – it was from a slaughterhouse. The stripe was painted on and the fake blood was added.

🎥 **Gone With The Wind** In the scene where Scarlett goes to look for Dr Meade to help her with Melanie's delivery, she goes to the hospital and encounters many wounded soldiers. For this scene, the film-makers were unable to get enough extras so for the injured soldiers lying in the distance they used dummies. The extras lay beside the dummies and by using strings linking the actors and the models the film-makers were able to move the dummies' arms and legs, making it look as though they were alive.

🎥 **Halloween** As this film was made with such a small budget, the prop department had to find the cheapest mask possible, which turned out to be a Captain Kirk mask from a costume shop. They removed the hair, painted the face white, changed the eyeholes – and created a movie legend.

🎥 **Hannibal** In the brain-eating scene, the piece of brain that Ray Liotta eats is really a piece of cooked chicken.

🎥 **Hot Shots!** The aircraft carrier used for much of the film was actually made of wood, and was built on the edge of a cliff. The cameras were always kept at the right angle to keep only the sea in shot.

🎥 **The Hulk** All of the Hulk's movements, from running to fighting, were done by the director, Ang Lee, wearing a motion-capture suit.

🎥 ***The Hunt for Red October*** "Heathrow" at the beginning of the film is actually Los Angeles International Airport with an added neon sign (which doesn't exist at the real Heathrow) and shot at night to conceal the rest of it.

The model of the *Red October* used in underwater scenes was never actually put under the surface. The undersea illusion was achieved through the use of smoke on the set, coupled with some digital effects. The sub was treated like a complicated puppet by hanging it from a grid overhead and using twelve wires, giving it the flexibility to turn and tilt in whatever position was required.

🎥 ***Indiana Jones and the Temple of Doom*** The enormous mine shaft was built in a large loop around a sound stage. To give the impression of an extended track, the lighting was changed after every loop to make it look different.

🎥 ***Innerspace*** After Scrimshaw and Canker are shrunk by fifty per cent there are a few scenes where they are seen with full-size actors. These shots were actually filmed using forced perspective. For the car scene, the rear of the car was actually twice as large as a normal car rear, and was a good distance further back. During the scene half-size hands and double-size heads were used. Using this method, the film-makers didn't have to worry about compositing two separate shots in post-production, so the shots could be completed quicker. Even in the final scene with the suitcase, the case was twice as large as it would have been in reality but the hand that closes it was real, closer to the camera and in sync with the closing. It took about twenty takes before it was perfect.

🎥 ***Jurassic Park*** To make the water in the glass on the dashboard "jump", a guitar string was strung from the underside of the dashboard to a bolt on the floor and then plucked.

🎥 **Kill Bill: Volume 2** Even though we can't really see her face, when Budd drags The Bride out of the truck, dumps her on the ground, then hauls her along the ground, that's actually Uma Thurman.

🎥 **King Kong** (1933) The actual King Kong model used for shooting was eighteen inches tall.

King Kong's bellow was made from the recorded roars of a lion and a tiger superimposed and played backwards.

🎥 **The King of Comedy** To encourage Jerry Lewis's anger in the scene where Rupert Pupkin crashes Jerry Langford's country home, Robert De Niro made anti-Semitic remarks. Lewis had never worked with Method actors, and was apparently shocked and appalled. But he delivered a very convincing performance.

🎥 **A Knight's Tale** A lot of research was done to create lances that would splinter in a realistic way, but would be weak enough not to injure the stunt riders. Each lance was scored down its length so that it would break more easily, and balsa wood was used for the tips. They were also hollowed out, then filled with dry pasta and chips of balsa to make the flying splinters more impressive.

🎥 **The League of Extraordinary Gentlemen** Some of the film's complicated photography required Townsend to do a scene backwards. He said, "It's a very quick clip where I steal Jekyll's vial. Basically, they wanted to end the shot with the hand on the vial. And because they have to be so specific, it's such a fast-speed shot and it just stops exactly, I couldn't do it normally. I had to walk into the room backwards and then go all the way back and pick up the vial backwards so that the camera could actually focus on that one. That was strange."

Lethal Weapon 3 The building that explodes at the beginning of the film (due to Mel Gibson messing with the bomb) was the old City Hall in downtown Orlando, Florida. In reality, only half the building collapsed as a result of the explosion.

Lethal Weapon 4 Jet Li performs a cunning move in this film, taking a gun apart before Mel Gibson can get a shot off. This is actually possible: on the right-hand side of the Beretta 92's frame is a button. Pushing this in releases the lever on the left-hand side, which then needs to be rotated downwards through ninety degrees. This will release the slide in order to strip the gun down for cleaning. While the complete disassembly can be done in one move, when we see Jet Li take the slide off Mel Gibson's gun the button has already been pushed down and the lever rotated partway, to make sure that the stunt can be performed without a lot of retakes.

The Matrix The shot towards the end of the film where the three Agents fire simultaneously at the newly resurrected Neo was achieved by having the three actors concerned shooting live rounds at some bulletproof glass, just inches away from the camera.

The Matrix Reloaded A freeway section was built on a military base in California specifically for the filming of the freeway chase scene. It was built as a continuous loop about two miles long. This also explains why some of the background repeats.

Carrie-Anne Moss did most of the motorcycle driving herself in the freeway scene.

Minority Report In the DVD extras, the sound designer for *Minority Report* explains that he stuck a contact mike on his fancy new washing machine to obtain the sound samples that became the sounds made by the maglev cars. In the scene where maglev cars

race down the side of a skyscraper, when Anderton stands on one end of his maglev car so that it is now carrying an unbalanced load it makes the clearly unmodified noise of a washing machine with . . . an unbalanced load.

Monsters, Inc. The voice of Roz, the Number One of the Child Detection Agency and the undercover secretary, is actually a man's.

Monty Python and the Holy Grail Almost all, if not all, the chain-mail armour in this film is actually thick wool, which was very uncomfortable for the actors because it was often raining where they were filming and the wool would become very damp and very heavy.

Monty Python's Life of Brian When Pilate is offering to "welease a pwisoner" the crowd mock him and roll about laughing when he names names with the letter "r" in them. The actual scene of the crowd rolling around laughing used extras copying what Terry Jones was doing up on a stage. The scene in the film is the second take – the first time they rehearsed it was apparently much better, but the camera wasn't rolling.

Moonraker The whole sequence of Bond, Jaws and the pilot falling out of the plane with Bond and the pilot fighting over just one parachute was filmed in genuine free fall, with the exception of a few close-up shots. The camera was fixed to the helmet of another skydiver, and the cameraman's own arms and legs are visible in some of the shots. The stuntmen wore parachutes hidden under their suits – the parachute that they were fighting over was actually a fake one, which ironically had to be discarded, along with their jackets, so that the stuntmen could get at the genuine parachutes they were wearing. Because they didn't have long during each take before they had to activate their real parachutes,

and it took time to get everyone into the right positions after they'd left the aircraft, it was only possible to shoot a few seconds of film each jump. The whole scene took five weeks to film, with a total of eighty-eight jumps, just to end up with around two minutes of finished film.

🎥 *Mr Smith Goes to Washington* To create his hoarse voice for the filibuster scene, James Stewart used bicarbonate of soda to dry out his throat.

🎥 *The Mummy Returns* In the scene where Brendan Fraser is stalking Imhotep and there's a sequence of shots alternating between pitch black and his illuminated face, getting the right look was quite tricky. The film-makers set up the camera on a dolly track, shut off all the lights, then tracked backwards while Brendan Fraser walked forwards, with two guys lighting the scene by using flame-throwers on either side of the camera, trying not to fall down the holes in the floor of the set all the time. Who needs CGI?

🎥 *Naked Lunch* To give the impression of an entire desert, seven hundred tons of sand was poured onto the floor of a former munitions factory.

🎥 *National Treasure* The scenes involving Andrew Jackson's White House in 1832 were actually filmed at the Daughters of the American Revolution Building in Washington DC.

🎥 *A Nightmare on Elm Street* The lamb that appears in the film could not be persuaded to run across the corridor, so it got a hefty kick up the backside to get it moving.

The sound of Freddy's knife-fingers scraping across metal was actually produced by scraping a steak knife across the underside of a metal chair.

When Nancy runs up the stairs and steps in the goop, pancake mix is used in the pre-cut holes (visible as a mistake) and the pancake mix was covered with Bisquick and chopped-up carpet.

A Nightmare On Elm Street 3: Dream Warriors One of the best bargains that the film-makers got was for an effect when Kristen enters the nightmare house and sees a roasted pig that starts barking at her. The special-effects guys were coming up with $300,000 estimates for how much an animatronic pig would cost: they could not afford it. Finally they got two real roasted pigs. One was got up to look like it was ready to eat, while the other was made to look demonic. A crew member who'd lost a coin toss got under the table and stuck his hand up into the dead demon pig to make it "work".

North by Northwest Alfred Hitchcock wasn't able to get permission to film inside the UN, so he got shots of the interior by using a hidden camera. Then all the relevant rooms were reconstructed on a sound stage.

Notting Hill Rhys Ifans didn't wash for two weeks in the lead-up to this movie in order to get himself into the role of Spike.

The Omen In the scene when the fishbowl falls to the ground, the film-makers used dead sardines painted orange instead of real goldfish.

The Phantom of the Opera (1989) The candles that light instantly as they come out of the water in the Phantom's Lair are not CGI effects – special candles that were sensitive to air were used. Luckily, the scene went well and the actors didn't mess up, because when they tried to reshoot the scene the candles didn't work a second time.

📽 *Pirates of the Caribbean: The Curse of the Black Pearl* When Barbossa and Jack are skeletons in the moonlight, their eyeballs are really theirs. They are the only parts of their bodies that are not CGI-animated.

In the blacksmith shop, Jack lifts up a sack filled with soot and sprays Will all over his face with it. The soot is actually chocolate powder.

📽 *Planet of the Apes* (1968) To help keep Charlton Heston from hurting his feet when he's running – he is barefoot for much of the film – he was fitted with rubber soles moulded to look like bare feet.

📽 *Pleasantville* The film was filmed entirely in colour and had the colour removed from the black and white sequences in post-production. When Bud covered up his mother by using grey make-up, the actual colour of the make-up he was using was green, as this could be more easily converted to black and white. By contrast, when Betty visits Bill Johnson at the soda shop she was already wearing the green make-up, which was then slowly removed to reveal her natural colour beneath it.

📽 *Poltergeist* In the swimming-pool scene with the mother near the end, the actress didn't know it but those weren't fake skeletons.

The scene where the ghosts stacked the chairs on the kitchen table was filmed in one take with no cuts. As the camera followed Diane Freeling to the kitchen sink, the crew members rushed to the table, put an already-built pyramid of chairs on the table and then took away the individual chairs.

📽 *Psycho* The blood in the infamous shower scene is actually chocolate syrup.

To get the right sound for a knife stabbing flesh, the crew stabbed a melon.

Raging Bull To visually demonstrate Jake La Motta's growing desperation and diminishing moral stature, the later boxing scenes were filmed by Martin Scorsese using a larger ring than in the earlier ones.

Raiders of the Lost Ark The rolling boulder in the opening scene was actually twenty-two feet in diameter and was made out of fibreglass.

Re-Animator The brains from the severed head were made from meat by-products, ground beef and fake blood. When the scene in the autopsy room was filmed – the severed head gets thrown through the doorway and then smashes against the hallway wall – the crew all kept down behind the cameras with rubbish bags over their clothes. No one knew just how much the brains would splatter around the place.

The Return of the Living Dead The "zombie" butterflies flailing about on the board after the gas leaks are really cut-out pictures from a butterfly book. The production designer waved a piece of cardboard off camera to create a draught and get them to move as if they were alive.

The Right Stuff To recreate the realistic shots of a spacecraft re-entering the earth's atmosphere, the visual-effects supervisor made a small model of a Mercury capsule. He coated this with flammable material, set it alight, then slid it down a long wire straight towards the camera, which was protected with a heat-resistant polycarbonate.

RoboCop 2 The Nuke-drug holders are actually old tape-cassette holders. The small capsules containing Nuke are actually

applicators for the drops that go on contact lenses, with water and red food-colouring in them.

Ronin In many of the stunt-car scenes you can see the actors apparently driving. The film-makers used right-hand-drive cars and fitted fake steering wheels on the passenger sides (as the driving all takes place in mainland Europe). The stunt drivers then did the real driving (not in shot, of course), and the actors copied their actions.

Rush Hour 2 In the scene where Chris Tucker and Jackie Chan are running on the highway with rubbish-can lids covering their unmentionables, they really had to do that. There was no way to close the road so they had to run on it while avoiding genuine traffic, not just extras or empty cars.

Saw The film-makers didn't have enough money in the budget for a dummy that could be used instead of a real person, so Tobin Bell had to lie on the bathroom floor, perfectly still, for six days of shooting.

Scanners To get the right effect for the exploding head, a latex cranium was filled with rabbit livers and dog food, then shot from behind with a twelve-gauge shotgun.

Seven Samurai Seiji Miyaguchi, who plays Kyuzo the master swordsman, actually had the least experience with sword-play of all the actors who play samurai in the film. In fact, he had never even touched a sword until a few weeks before shooting of the film started. Most of his fight scenes rely on clever editing to make him appear to be a master.

The Silence of the Lambs The dead female body in the funeral home was played by a real actress, not a mannequin.

Because the bug cocoon would be in her mouth until it was taken out in the middle of the examination, the prop master made it from a mixture of Tootsie Rolls and Gummie Bears. This way, if the actress accidentally swallowed the cocoon it wouldn't do her any harm.

🎥 *Sin City* Because the whole movie was shot against a green screen, some bits of colour proved difficult. The character of Yellow Bastard was especially hard, as yellow bled into the green screen and couldn't be separated cleanly. To get around this, Robert Rodriguez painted him blue, then turned him yellow in post-production.

Getting the right look for the white blood proved a challenge, as the blood normally used in films didn't come out properly. Instead the crew used fluorescent red liquid and shone ultraviolet light on it. This was then turned white in post-production.

Each section of this film was shot separately, so new cast members were added and edited into the stories all the time. Often separate footage was composited in post-production to look as if it was all shot at the same time. For example, Marv takes Wendy to Nancy's home. Jessica Alba had not yet been cast as Nancy when the other two shot the scene, so her footage was added in later. The same is true of the scene between Marv and Cardinal Roark – Rutger Hauer was the last person in the film to be cast and wasn't on set for the initial filming of that scene.

🎥 *Singin' in the Rain* When this classic scene was first shot the rain did not show up on film so it was reshot using a mixture of rain and milk.

🎥 *Speed* When the gap that the bus has to jump is shown for the first time there are birds flying through it. The bridge was actually complete and intact (there is a solid shadow behind it) – the missing section was removed digitally, and the birds were edited in.

Star Wars The sound of Luke's land-speeder was made by mixing a recording of the sound of a highway in Los Angeles with that of a vacuum cleaner.

Star Wars: Episode I – The Phantom Menace The sound of Watto's wings flapping is a looped recording of sound designer Ben Burtt opening and closing an umbrella.

Star Wars: Episode V – The Empire Strikes Back The scene in the Wampa cave in which Luke uses the Force to get his lightsabre back was filmed by having Mark Hamill throw the sabre prop into the snow, and then running the film backwards.

Straw Dogs Sam Peckinpah wasn't happy with the initial take of Dustin Hoffman's first entry into the local pub, as he felt that the other actors weren't reacting quite right. He suddenly had a brainwave and did one take with Dustin Hoffman coming in wearing no trousers, with no advance warning to the other actors. Peckinpah got his desired reaction, the one that ended up in the finished film.

Superman A long period of experimentation was necessary to develop the best way to show Superman flying. Among the methods tested were: simply catapulting a dummy into the air; painting a remote-control model aeroplane as Superman; and simply animating the flying sequences. The producers eventually settled on a combination of rear projection and specially designed zoom lenses that could create the illusion of movement by zooming in on Christopher Reeve, while also making the back projection appear to withdraw.

To produce the effect of Clark Kent running down the dirt road after jumping in front of the train, the film-makers simply attached a bag of dirt to a motorbike and got someone to ride the bike along at speed.

To get the effect of the young Clark Kent kicking a football into orbit, an air cannon was put underground and loaded with the football. Then the cannon was fired.

🎥 *The Terminator* Most of the car chases were filmed at normal speed and then slightly accelerated for the final print. To add even more of a sense of speed, other cars drove alongside out of shot. Fitted with revolving lights, they gave the impression that the vehicles were passing street lamps and other light sources even faster.

🎥 *Terminator 2: Judgment Day* The pit of roiling molten steel where the Terminator and T-1000 meet their ends is actually a Plexiglas trough filled with a mixture of water, powdered sugar and mineral oil, lit from below by orange lights.

So that he didn't have to use a split screen, director James Cameron hired twins to play the security guard and his T-1000 double at the hospital. Linda Hamilton's twin sister Leslie Hamilton Gearren was used in the scene where the T-1000 is disguised as Sarah, although since the focus is on the T-1000 in those shots Linda Hamilton actually plays the robot, with her sister playing Sarah.

To make the truck that the T-1000 drives towards the end sound even scarier, sound designer Gary Rydstrom mixed some lion roars into the engine noise.

To make the sound of the T-1000 morphing, a condom was put over a microphone and it was then dipped into oatmeal.

🎥 *Titanic* The enormous model of the *Titanic* was only half a ship (the starboard side). As the real ship was originally moored with its port side towards land, all the shots at the start of the film were achieved by making all the costumes and signs for that section with backwards insignia and lettering, then flipping the film in post-production.

Top Secret! Cows hate having things put on their feet, so to give the impression of one wearing two pairs of Wellington boots the soles were cut out and then the main lengths of the boots were attached to the cow's legs using Velcro.

True Lies In the scene where Arnold Schwarzenegger has rescued Jamie Lee Curtis from the limo and she is flying over the ocean hanging from Arnold's hand, Curtis is actually the one doing the stunt.

The Usual Suspects Kevin Spacey glued his fingers together to give a realistic paralysed effect.

Videodrome The sequences involving the chest-slit were achieved by having James Woods "built into" a sofa with the chest-slit apparatus glued onto him. Woods swore he would refuse to work with anything that had to be glued onto him ever again.

Volcano The lava was made primarily of methylcellulose, the thickening agent used in fast-food milk shakes, and the ash was made mostly of ground newspaper.

Withnail & I When Withnail drinks a bottle of lighter fluid, the can had been filled with water in rehearsals. However, to get a better reaction from Richard E. Grant when it came to the actual take, director Bruce Robinson, unknown to Grant, replaced the water with vinegar. The vomiting afterwards was pre-planned and fake, however.

X-Men 2 The wall of ice that separates Wolverine and Stryker in the mansion after the attack where they meet for the first time was genuine ice, weighing three and a half tons.

IMPROVISATIONS

More dialogue in the movies is improvised than you might think — just because we see it on screen in finished form doesn't mean that the script remained unsullied the whole way through. Often script ideas get worked on further during shooting, and occasionally whole extra sequences are added because someone just thought of them and decided to try them out.

American Graffiti The entire movie was filmed over twenty-nine consecutive days, and George Lucas generally didn't allow scenes to be reshot if they came out sufficiently plausible on the first take. Thus, entire scenes in the movie have botched lines and ad libbed parts, the best of which is probably Toad's boasting about Milner's racing ability after Falfa rolls his car: Charlie Martin Smith couldn't remember most of his lines when they shot this scene, and so made almost all of them up on the spot.

Being John Malkovich When John Malkovich meets someone in the restaurant who says, "You were really great in that movie where you play that retard" that scene was improvised. According to Willie Garson, who played the man to whom Malkovich is talking, director Spike Jonze had told him to use the word "retard" as often as possible.

The Deer Hunter When Nick spits in Michael's face, that was improvised by Christopher Walken. Director Michael Cimino convinced Walken to do it, and Robert De Niro was completely taken aback, as is clear from his reaction. De Niro was so incensed by it that he almost stormed off the set.

Eternal Sunshine of the Spotless Mind When Joel and Clementine watch the circus go through the streets, the scene is

there because the film crew and cast happened to be working nearby and director Michel Gondry decided on the spur of the moment that it could be incorporated into the film. He's said that the part where Clementine suddenly disappears is one of his favourite parts of the film – Jim Carrey didn't know Kate Winslet was going to vanish so the look of surprise and sadness on her face is completely genuine. The sound cuts out in the film – at that point Jim Carrey's actually saying "Kate?" while looking for the actress.

From Dusk Till Dawn The famous exchange "Welcome to slavery" – "No, thanks, I've already had a wife" was improvised by George Clooney. Director Robert Rodriguez never meant to include it in the final cut but, when the studio put the line in a trailer, he felt that he had to keep it in the film as well.

Full Metal Jacket Most of R. Lee Ermey's dialogue in the Paris Island sequence was improvised. While filming the scene when he disciplines Pvt. Cowboy, he accuses Cowboy of being the type of man who would have sex with another man "and not even have the goddamned common courtesy to give him a reach-around". Stanley Kubrick immediately stopped the take and walked over to R. Lee Ermey to ask him, "What the hell is a reach-around?" R. Lee Ermey politely explained what it meant. Stanley Kubrick laughed and did a retake of the scene, saying the line could stay in.

Garden State Much of the scene with Zach Braff and the doctor in his office was ad libbed by Ron Leibman. Leibman made up patting Braff on the knee and saying, "Hey, you're alive" on the spot, and Braff actually did jump from it. He also did some research by calling other doctors, and threw in the line about taking off his shoes and scratching his feet at the very last moment, something doctors actually do.

🎥 *Ghostbusters* When Venkman and Spengler are talking about experiments, we hear that Spengler once tried to drill a hole in Venkman's head. Spengler's line "That would have worked if you hadn't stopped me" was ad libbed on the spot by Harold Ramis.

In the party scene when Louis Tully is mingling with his party guests and is talking about what everything cost and how buying in bulk is better value, that scene is one continuous shot and was almost entirely improvised by Rick Moranis.

🎥 *The Godfather* The specifics of Don Corleone's death in the garden were improvised. The child playing his grandson wasn't performing properly, but when Marlon Brando started playing with the orange it all came together.

🎥 *The Godfather: Part II* Danny Aiello's line "Michael Corleone says hello" was improvised in the first take – he later said it came out of nowhere. When the shot finished the director asked what he had just said. Danny Aiello explained and it was decided that the line fitted perfectly, so another take was done with it included.

🎥 *GoodFellas* The dinner scene where Henry, Tommy and Jimmy have dinner with Tommy's mother was almost completely improvised, including Tommy's request to borrow his mother's butcher's knife, and Jimmy chipping in "Hoof" when Tommy's trying to describe what is apparently stuck in the grille of the car.

When Paulie confronts Henry about drug dealing after Henry's release from jail, Paul Sorvino improvised the slap to Ray Liotta's face. You can see Ray Liotta blink and look genuinely surprised.

🎥 *The Graduate* When Dustin Hoffman and Anne Bancroft first encounter each other in the hotel room, Anne Bancroft did not know that Dustin Hoffman was going to grab her breast. He had

decided beforehand to do it, because it reminded him of boys trying to "accidentally" grab girls' breasts in the hall at school while putting their jackets on. When he did this during a take, director Mike Nichols began laughing loudly off screen. Dustin Hoffman started laughing as well, so rather than stopping the scene he turned away from the camera and walked to the wall, banging his head on it to try to stop himself laughing. Nichols thought it was so funny that he left it in.

🎥 *Heat* Al Pacino's line "Because she's got a great ass!" was improvised on the spot, and Hank Azaria's look of shock and confusion was totally genuine.

🎥 *Highlander* The scene in the church between Kurgan and MacLeod was shot at night, with the approval of the priests who ran it. However, Clancy Brown, who played Kurgan, improvised his lines, and the priests thought they were so sacrilegious that they stood just off camera making the sign of the cross while he said them.

🎥 *A Knight's Tale* The scene where Mark Addy says "Yayyyy!" because the audience makes no reaction to Chaucer was improvised by Addy because the extras didn't speak English (they were Eastern Europeans) and had no idea when to cheer.

🎥 *Last Tango in Paris* Marlon Brando didn't like a lot of his scripted dialogue so he ended up improvising most of his lines.

🎥 *Man on Fire* When Pita is doing her homework and notices Creasy smiling, they play a game to see who smiles first. This scene was completely improvised.

🎥 *The Mask* When Jim Carrey tries to get the keys away from Milo, the dog refusing to let go of them is unplanned. The mutt just wouldn't let go so the scene was ad libbed.

🎥 *One Flew Over the Cuckoo's Nest* In the scene where Dr Spivey is interviewing McMurphy, the whole dialogue is improvised. Spivey (Dr Dean Brooks) was the actual doctor of the institute concerned in real life, and was simply told to interview Jack Nicholson (McMurphy) as if he was a real patient. Nicholson had to improvise and get from the beginning of the scene to the end under his own steam, so to speak.

🎥 *Pretty Woman* The scene where Edward offers Viv the necklace and shuts the box on her fingers wasn't scripted – Richard Gere did it just for a laugh. When he does it Julia Roberts laughs and looks up and around (i.e. at the film crew) – as far as the script was concerned there wasn't anyone there for her to look at.

🎥 *The Quick and the Dead* When Gene Hackman slaps Sharon Stone quite lightly, that wasn't in the script – he improvised it and Sharon Stone's reaction is real.

🎥 *Reservoir Dogs* Quentin Tarantino did not actually give a script to the actor playing the police officer (Kirk Baltz) for the scene in which Mr Blond was going to set him on fire. Instead, while rehearsing the scene, he basically just said, "Convince this man not to set you alight." While Kirk Baltz was going through the obvious lines – like "Please don't! Stop!" – he remembered that Michael Madsen (who plays Mr Blond) and his wife had just had a baby, and said, "I have a little kid at home." As soon as Baltz said that Madsen immediately stopped, and did everything he could to convince Tarantino not to let Baltz use that line. But Tarantino liked it so much that he made Madsen use it.

🎥 *Rocky* Adrian hesitating to kiss Rocky in his apartment after their date together wasn't originally scripted that way: Talia Shire was suffering from flu during filming, and she was afraid of

making Sylvester Stallone ill. What resulted was, ironically, a better-acted scene than had been originally anticipated.

🎥 **Roman Holiday** When Gregory Peck puts his hand into the Mouth of Truth and withdraws it tucked into his sleeve, the scream that Audrey Hepburn gives is real. The prank was unscripted, but the actress's reaction was so perfect that it was left in.

🎥 **Star Wars** All the dialogue when Han is on the console talking to some of the commanders was ad libbed. Harrison Ford deliberately didn't learn the lines so that his dialogue would sound more spontaneous.

🎥 **They Live** The fight between Nada and Frank was originally supposed to last only twenty seconds. But the two actors decided to fight it out for real, apart from faking any punches to the face. John Carpenter was so impressed that he kept the scene intact, all five minutes and twenty seconds of it.

🎥 **When Harry Met Sally ...** When Harry and Sally are in the museum and Harry says, "For the rest of the day, we are going to talk like this ..." the last piece of dialogue is ad libbed. "But I would be proud to partake of your pecan pie" is not in the script. Meg Ryan laughs and looks off camera at the director but she was prompted to go along with Billy Crystal, which is why she seems to be slightly off balance.

🎥 **X-Men** Hugh Jackman improvised Wolverine's line: "What do they call you, 'Wheels'?" The original and far less funny line was: "What do they call you, 'Baldie'?"

![clapperboard icon] TAKE 12 **INCLUDED ACCIDENTS**

The course of true love never did run smooth, and filming very rarely does either. Quite often someone will trip, mess up a line or crash a car (possibly all three), and the blunder will wreck a scene. By no means always, though – every so often something can go so wrong in such a good way that it stays in the finished film.

🎬 *1941* When Wild Bill Kelso slips and falls off the wing of his aeroplane just as he is about to take off, it wasn't in the script. John Belushi just slipped as he was getting into the plane, but it was kept in the film as it suited his character.

🎬 *American Graffiti* When Terry Fields is being introduced, he drives up on his scooter and has quite a bit of trouble parking it. This is because Charles Martin Smith actually didn't know how to change gear manually. The small accident he has is real: he crashes, looks up towards the camera (at George Lucas) and continues the scene. Lucas motioned for him to continue, because the crash looked so interesting.

When a car with girls in it pulls up at traffic lights beside John and Carol's car, one of the girls throws a water balloon. In the script it was supposed to hit John, but it actually hit Mackenzie Phillips, the actress playing Carol. She kept in character, though, so George Lucas decided to keep the shot.

🎬 *American Pie 2* In the scene where the boys are trying to persuade the "lesbians" to do things for them, the actor playing Finch was laughing so much at Stifler's behaviour that he had to be edited out of various shots. As a result, lots of the shots are just of Stifler and Jim, even though Finch is right beside them.

🎥 *Amores Perros* The car crash was shot using nine cameras at once, including two on nearby rooftops and one hidden in a rubbish bin, to make sure that it was all captured. The black car was driven by a stunt driver, while the model's car didn't have a driver, just a remote-controlled animatronic dummy. During a practice run the black car accidentally ripped the back bumper off the model's car, but it was fixed back on and filming continued. During the next take the model's car was spun around, overshot the pre-planned target by over 100 metres, and collided with a taxi parked beside the road. This is the take used in the finished film.

🎥 *Annie Hall* Woody Allen sneezing into the cocaine was an accident, and was not scripted. When it was shown to preview audiences, people laughed so much that Allen decided to leave it in. He had to add extra footage in order to prevent people who were still convulsed with mirth missing the following jokes.

🎥 *Apocalypse Now* Martin Sheen was genuinely drunk in the scene when Captain Willard is drinking alone in his room. Everything he did in that scene was due to his being drunk, and it actually happened. For example, when he punched the mirror he actually cut his hand, as it was real glass. He also started crying and tried to attack the director, Francis Ford Coppola.

🎥 *Blade Runner* When Deckard prevents Rachael from leaving his apartment, he pushes her away from him quite forcefully. Sean Young later said that Harrison Ford pushed her too hard and it made her angry – the look of pain and shock on her face was genuine.

🎥 *Bullitt* In the restaurant scene near the beginning of the film, the actor playing the waiter accidentally flips the corner of the menu into Steve McQueen's eye, but the shot was left in the finished film.

🎥 *Cape Fear* (1961) Actress Polly Bergen suffered some minor bruising in a scene where she has a struggle with Robert Mitchum. He was meant to drag her through various doors on the set, but a crew member had mistakenly left all those doors locked so that when Mitchum tried to push Bergen through them she ended up actually being used as a battering ram to force them open.

🎥 *Carrie* When the fire hose "kills" Norma Watson, the water pressure was so intense that it actually burst her eardrums and knocked her unconscious.

Betty Buckley really slapped Nancy Allen across the face during the detention scene. Brian De Palma wanted the right reaction.

🎥 *Chinatown* After several takes of the scene where Jack Nicholson slaps Faye Dunaway, it still wasn't coming across properly. Dunaway told Nicholson to actually slap her, which he did — and that is the version which made it into the film.

🎥 *Die Hard* When Bruce Willis misses one of the vents in the elevator shaft, this was unintentional. The stuntman missed the vent by mistake, but John McTiernan left the shot in to give viewers a little scare.

🎥 *Dog Soldiers* The rifle used by Spoon, then by Terry later on, didn't work properly when firing blanks instead of live ammo — not enough "blowback" discharge to activate the gun's automatic recocking mechanism. In some scenes in the house when Terry's firing the weapon, he has to work the bolt manually in order to put the next round in the chamber.

In the scene where Wells asks Cooper to knock him out, Kevin McKidd throws a stage punch the first time but misjudges the distance for the second blow and catches Sean Pertwee on the

nose. Pertwee didn't feel the punch, however, as he really was drunk for that scene.

Dr Strangelove The shot in the War Room where General Turgidson slips, falls, rolls and gets back onto his feet was unplanned. George C. Scott was so seamless in keeping his dialogue going that Kubrick decided to keep the shot in the final version.

Dune During the filming of the dream sequence, the Baron approaches Duke Leto and scratches his face. Jürgen Prochnow had special-effects equipment attached to his face so that, when the Baron scratched it, green smoke would emerge from his cheek. Although it had been thoroughly tested, the heat generated by the device ended up giving Prochnow first- and second-degree burns on his face.

E.T. The Extra-Terrestrial Unusually, this entire movie was shot in sequence. Steven Spielberg did this so that he could get an honest reaction from Elliott when E.T. leaves at the end.

Edward Scissorhands In the scene where Vincent Price dies, he genuinely fainted during the actual filming. Tim Burton quite liked the morbidity and decided that it worked within the context of the scene. So he kept it in.

The Exorcist In the scene where Regan's mother is supernaturally blasted away from the bedside, she is being yanked back by the crew using a length of rope. After dozens of takes director William Friedkin was still unhappy with the look of the shot and ordered the crew to haul her more fiercely. The scream in the shot that made the cut was one of genuine pain and required no dubbing for effect.

Fight Club The scene showing Tyler and The Narrator hitting golf balls outside the house is actually footage of Ed Norton and Brad Pitt really drunk and hitting things at the on-site catering van.

When one of the members of the Fight Club is trying to start a fight with any passing member of the public and sprays the priest with a hose, the camera briefly shakes at the top of the screen. The cameraman couldn't stop himself laughing and moved the camera accidentally.

The French Connection During the subway chase scene Hackman collides with another vehicle. This wasn't supposed to happen, but it looked very realistic (for obvious reasons) and fitted with the scene, so the collision was kept in the film.

The Godfather Lenny Montana, the actor playing Luca Brasi, was so nervous about acting in a scene with Marlon Brando that in the first take they had together he messed up his lines. Francis Ford Coppola felt that Montana's real nervousness worked well and so he used it in the final version. The scenes of him practising his speech were filmed later, to give more context to his being flustered.

Gone With The Wind In the scene where Rhett hands Mammy a glass of whiskey, she sniffs it before drinking. When the scene was originally filmed, tea was supposed to have been in the glass but Clarke Gable (Rhett) substituted real whiskey as a joke. The actress playing Mammy downed the glass, not realising what was in it. The scene had to be reshot, with tea this time, and obviously the actress didn't trust Gable after the first incident.

The Goonies The reaction from the Goonies when they first see the pirate ship is their real reaction. Steven Spielberg didn't want them to see the ship before shooting the scenes concerned

because he wanted a "from-the-guts" reaction. Apparently the kids were a little "vocal" in their shock at seeing the ship and the scene had to be reshot – minus the bad words.

Irreversible In the party scene shortly after the rape (or before it, given the backwards nature of the film), when someone asks Vincent Cassel what his name is he replies, "Vincent" instead of his character's name, Marcus. He quickly covers this up by saying "Just kidding" so that the long and complicated shot would not have to be redone.

A Knight's Tale The jousting between two knights in the first scene of the movie actually shows Heath Ledger's stunt double involved in an accident. The shot was originally intended for a later scene – Ledger's opponent's lance slipped off target, hitting the stuntman in the head and knocking him to the ground, out cold.

Legends of the Fall When shooting the scene where Isabelle Two is shot and Tristan gets beaten up by the policeman, the actor playing the policeman accidentally really did hit Brad Pitt on the head with his baton, giving him a black eye. Shortly after that, the tennis scene near the beginning was shot and Brad Pitt still had his black eye. A couple of lines about his "shiner" had to be added in to explain it.

Lord of the Rings: The Fellowship of the Ring During the scene before Bilbo's party, when Gandalf and Bilbo are inside Bag End, Gandalf hits his head on a beam when entering Bilbo's study. This was actually unintentional, but Ian McKellen did such a good job of acting through it that director Peter Jackson left it in the movie.

M*A*S*H In one of the opening scenes, a corpsman is running from a helicopter while carrying one end of a stretcher and

he accidentally slips and falls. The director thought it was an appropriate blunder and decided to leave it in.

Mad Max 2 One of the more spectacular "stunts" in the film was actually a terrible accident. When one of the raiders is riding a motorcycle he hits a car, flies off the bike, smashes his legs against the car and cartwheels through the air. It bears repeating that this was a *real* accident: the intended stunt was just to have the stuntman fly over the top of the car *without* hitting it. But the near-fatal incident looked so dramatic that it was kept in the movie. The stuntman broke his leg badly, but survived.

Monty Python's Life of Brian When Michael Palin, as Pontius Pilate, was daring his soldiers to laugh about Biggus Dickus's name, he really *was* daring them. The extras playing the soldiers were told not to laugh during the scene but were not told what Palin would be doing or saying.

The Mummy Near the beginning of the film, when Rick gets hanged, the wide shots used are of Brendan Fraser's stunt double. But in the close-up shots it really is Fraser. His eyes in the close-up just before he gets cut down are rolled nearly right back in his head. This is because he really was almost asphyxiated and actually collapsed after that scene was shot.

Night of the Living Dead Some of the groans made by S. William Hinzman in the cemetery when he's wrestling with Russell Streiner are authentic. During the fight, at one point Streiner accidentally kneed Hinzman in the groin.

A Nightmare on Elm Street The reactions of the actors when the car roof comes up are real – Wes Craven increased the speed at which the roof closed, and the actors weren't expecting this.

🎥 *Oldboy* Just after Dae-su Oh stops Mi-do from reading his diary he bangs his head. This was not in the script, but the actress playing Mi-do remained unfazed and continued on with her lines. The director has since said that he kept the scene in for its comical and emotional value.

🎥 *The Omen* To encourage the baboons to attack the car in the Windsor Safari Park scene, a Park official sat in the back seat of the car with the head baboon, which made all the baboons outside go crazy. Lee Remick's exclamations of fear as the baboons attack the car are genuine.

🎥 *Police Story* Jackie Chan suffered burns on his hands during the scene where he slides down a pole in the mall. The Christmas-tree lights were plugged straight into the mains instead of into the low-voltage battery that should have been used. The scene was still used in the film.

When the villains were thrown through the bus window and fell onto the ground, this was actually an accident. The plan was for them to fall onto the car directly in front of the bus, but because of the bus's air brakes malfunctioning slightly it moved a short distance backwards, creating a gap between it and the car.

🎥 *The Punisher* Rebecca Romijn-Stamos said in an interview that, in a scene where she's sewing up a knife wound in Thomas Jane, she accidentally pushed the needle in too far and ended up sewing a couple of real stitches into his body, instead of just into the fake wound.

🎥 *Raging Bull* In a scene where they were sparring, Robert De Niro accidentally broke Joe Pesci's rib. This shot was actually included in the film – Pesci gets hit in the side, groans and the film quickly cuts to a different angle.

Requiem for a Dream During Ellen Burstyn's impassioned speech about how it feels to be old, cinematographer Matthew Libatique accidentally allowed the camera to drift off-target. Director Darren Aronofsky called "Cut" and asked him why that had happened. He then realised that the reason Libatique had let the camera drift was that he had been crying during the take, fogging up the camera's eyepiece so that he'd been unable to see exactly what was going on. This was the take used in the final print.

RoboCop In the attempted-rape scene in the alleyway, screenwriter Edward Neumeier originally wrote it so that RoboCop would shoot just past the victim's cheek, hitting and killing the rapist. When the actors got into position, director Paul Verhoeven noticed how the rape victim's legs were positioned, with a reasonable gap between them, which gave him the idea of having RoboCop shoot between her legs, hitting the rapist in his genitals. Neumeier loved the idea and that was how the scene was actually played out.

Rope Unusually, this movie was filmed in just nine separate takes. As the takes were so long, everyone worked hard to avoid making any mistakes. At one point the camera dolly ran over a cameraman's foot, breaking it. Rather than stopping the filming, the unfortunate man was gagged and dragged off the set. On another occasion, someone was meant to put a glass down on a table but missed it. One of the crew had to rush in and catch the glass before it hit the ground. Both of these takes made it into the final film.

Saving Private Ryan The majority of the extras in the movie were from the Irish Army and the FCA (a military organisation). In the opening scenes, where the American soldiers are in the boats before landing in France and going into action against

German forces, several of the soldiers are puking their guts out. This wasn't scripted, and fake vomit was not used – many of the extras really did suffer from bad seasickness while filming that scene, and their genuine distress was kept in.

Scarface In the final scene, when Tony's house is being raided, there is a moment when he attempts to grab a gun and then lets go immediately. In fact, the gun was so hot that it actually burned Al Pacino's hand and he was unable to perform again for a week or two. Director Brian De Palma used that extra time to film the scenes of the shooters moving through the house.

Scream When Sidney (wearing the Scream costume) bursts out of the cupboard and stabs Billy twice with an umbrella, the stuntman in the costume was supposed to hit padding on Skeet Ulrich's chest with a real umbrella. The first hit made contact with the pad as planned, but the second one slipped off and actually struck Ulrich right in the chest. Wes Craven kept the shot in because of its realism – you can see the genuine pain in the way that Skeet Ulrich reacts.

Towards the end of the film the phone slips out of Billy's blood-soaked hand and hits Stu in the head. This was completely unintentional, but Matthew Lillard acted through it so convincingly that Wes Craven kept it in.

Sleeping with the Enemy When Laura's husband hits her at the beginning and she falls to the floor, it really is Julia Roberts who falls, not a stunt double. She banged her head on the floor quite badly.

Speed When Keanu Reeves breaks the glass on the door of the bus near the start of the film it is an accident. But as it fits the scene it was left in the finished film.

📽 *The Texas Chainsaw Massacre* Sally Hardesty is chased by Leatherface through scrub and undergrowth, and gets blood on herself and her clothes. A lot of that is actually the actress's own blood – Marilyn Burns really did cut herself quite badly on the branches as she was running.

📽 *Titanic* When Jack Dawson says, "Sit on the bed … I mean the couch," it says in the script: "Sit on the couch." Leonardo DiCaprio really made that mistake, but since it fitted the mood of the scene it was kept in.

📽 *Tombstone* In the scene where Sam Elliott is shot, staggers into the bar and falls, when his colleagues pick him up they accidentally slam his head against the underside of the bar.

📽 *True Lies* Arnold Schwarzenegger actually broke his hand while shooting the scene where he yells at Tom Arnold, "Give me the goddamn page!" and smashes the van window with his fist. The van's front window was made of fake glass and Schwarzenegger was meant to punch through that, but instead he hit the rear window – breaking it, but also injuring his hand in the process. This is actually the take that made it into the film, not least because of Tom Arnold's genuinely surprised reaction.

When Jamie Lee Curtis is performing her striptease, she tries to grab the bedpost but can't keep hold of it and falls over. This wasn't scripted – apparently she was so nervous about doing the scene that she had slightly sweaty hands, so when she grabbed the post her hand slipped and she fell flat on the floor. Arnold Schwarzenegger starts to get up to help her stand, but Curtis recovers quickly and decides to finish out the scene, so he sits back down. James Cameron liked how it turned out so much that he left it in.

🎥 *Wild at Heart* Willem Dafoe really does urinate in the toilet when he goes to visit Laura Dern and asks to use the bathroom. Apparently, Dafoe had drunk a lot of water that day and really needed to take a leak. Only later did he find out that the toilet was not actually plumbed in and that some poor crew member had had to clean it.

🎥 *Willy Wonka & the Chocolate Factory* At the beginning of the movie, when the candy-store owner is singing the candy-man song, there's a spot towards the end of the song where he lifts up his counter to let all the kids in. The little blonde girl gets walloped on the chin by the counter flap.

🎥 *The World is Not Enough* As Bond is racing along the Thames in his speedboat, he whips round one bend of the river and completely soaks two traffic wardens with his spray. The one standing up had been the star of a reality-TV show on the BBC about traffic wardens. He'd been given a cameo part in the movie but wasn't told of the impending splash – the shocked exclamation that he utters is his natural reaction.

INSPIRATION

Everything comes from somewhere, and that's especially true if you're making a film. Anyone can create a standard plot, but if you want something a bit special you'll need some inspiration. It can come from some unlikely places ...

8 Mile During the movie Eminem shoots paintballs at a police car. In real life Eminem had his first brush with the law when he was twenty – for shooting paintballs at a police car.

Airplane! The film is largely based on the 1957 film *Zero Hour!*, so closely in fact that the producers of this film had to buy the rights to the earlier one first. *Zero Hour!* also had a main character called Ted Stryker and contained risible dialogue such as: "We have to find someone who can not only fly this plane, but who didn't have fish for dinner." It was also the source of the line: "I guess I picked the wrong week to give up smoking," although it left it there, unlike *Airplane!* which added drinking and sniffing glue to the list of habits. Of the *Airport* series, the main inspiration for *Airplane!* is *Airport 1975*, which also features a stewardess forced to fly the plane, a girl needing a kidney transplant and a singing nun.

Alien The name of the space-exploration and mining company is "Weyland Yutani". The inspiration for this was some ex-neighbours of director Ridley Scott – he hated them, so decided to name an evil corporation after them.

The Bourne Identity The name "Bourne" was taken from Ansel Bourne, who was a preacher in Rhode Island. His was the first documented case of "dissociative fugue", which is similar to the condition that Bourne has in the film. One day in 1887 Ansel completely forgot who he was and moved to Pennsylvania, starting

a new life under the name Brown and opening a convenience store. Roughly three months later, he suddenly remembered his life as Bourne, but had forgotten his entire time as "Brown". Perhaps unsurprisingly, he was rather confused about why he was in Pennsylvania.

Brief Encounter Carnforth railway station was chosen for this film partly because it was so far away from the South-East of England that if an air-raid attack had been detected there would have been enough time to shut off the lighting equipment to comply with wartime blackout restrictions.

Clerks The distinctive font/style of the *Clerks* logo is made up of letters cut from different magazines and food items. The "C" comes from *Cosmopolitan* magazine, the "L" is taken from *Life* magazine, the "E" is from *Rolling Stone* magazine, the "R" is from Ruffles potato chips, the "K" comes from a Clark Bar, and the "S" is from a Goobers box.

A Clockwork Orange Stanley Kubrick introduced Basil, Alex's pet snake, only after he discovered that Malcolm McDowell is terrified of snakes in real life.

The scene where Alex has sex with the two girls in fast-forward mode wasn't done as an artistic statement: Stanley Kubrick just sped the scene up so that he could get it past the censors and the MPAA.

Delicatessen Jean-Pierre Jeunet got the idea for a cannibal butcher in *Delicatessen* while living above a boucherie. Every morning at seven a.m. he would hear the clashing metal sound of knives and a voice would shout, "Chop chop!" His girlfriend said the butcher was carving up the neighbours, and it would be their turn next week.

🎥 ***Dirty Harry*** Around the time of this film, there was in San Francisco a serial killer nicknamed the Zodiac Killer, very similar to "Scorpio", who was actually murdering people. Due to the relevance of the character and to Andrew Robinson's convincing portrayal, Robinson received at least one death threat, and ended up having to get an unlisted phone number.

🎥 ***Double Indemnity*** The scene where Neff and Dietrichson can't get their car started after the murder was not originally scripted. It was added by Billy Wilder after his own car wouldn't start one day after shooting.

🎥 ***Dr Strangelove*** Peter Sellers's fellow Goon Spike Milligan suggested the sequence at the end, when "We'll Meet Again" by Vera Lynn is played over shots of nuclear explosions.

The glove that Peter Sellers wears when playing Dr Strangelove came from the personal collection of director Stanley Kubrick. Sellers had seen Kubrick wearing them while handling hot lights on the set and thought they looked suitably sinister, so he wore one on his uncontrollable hand to make Strangelove even more creepy.

The interior of the B-52 bomber was apparently so accurate that the US Defense Department demanded to know where Kubrick had got the information. The story was that he had seen photos of it in a British magazine.

🎥 ***E.T. The Extra-Terrestrial*** Steven Spielberg originally wanted to make a much darker movie in which aliens terrorised a family in their home. As the idea of a friendlier alien developed, the first concept got reused as *Poltergeist*, which Spielberg was heavily involved in.

🎥 ***Ed Wood*** Tim Burton said that he was drawn to making this film because of the similarities between Ed Wood's relationship

with Bela Lugosi and Tim Burton's own friendship with Vincent Price late in that actor's life.

For Your Eyes Only The sequence before the credits pokes fun at Kevin McClory, who at the time owned the rights to the character of Blofeld and to the organisation SPECTRE. The bald man in a wheelchair, while not named, is obviously mean to be Blofeld: killing him off right at the start was producer Albert R. Broccoli's way of making it clear that Bond could be successful without the presence of Blofeld or SPECTRE.

Friday The neighbourhood where the film takes place contains the same street where the film's director, F. Gary Gray, grew up in South Central Los Angeles. Principal locations that were used for filming included houses of old friends of the director. The scene where Deebo punches Red into the air takes place at the actual house in which F. Gary Gray grew up.

Full Metal Jacket R. Lee Ermey, a former US Marines drill instructor, was initially hired just to advise on how to drill in the correct style. He gave a demonstration on tape, yelling obscene abuse and insults for fifteen minutes while having tennis balls and oranges thrown at him. He managed not to stop, repeat himself or even flinch. Director Stanley Kubrick was so impressed with his performance that he cast him as Gunnery Sergeant Hartmann.

The Godfather The unique voice that Marlon Brando used for Don Vito Corleone was based on that of a real-life mobster named Frank Costello. Marlon Brando had seen him on TV in 1951 during some televised Congressional hearings, and used his husky whisper in the film.

Harry Potter and the Philosopher's Stone Platform 9¾ was actually filmed on platforms 4 and 5 at King's Cross station.

J.K. Rowling has admitted that when she was writing the first books she confused the layout of King's Cross when she came up with platform 9¾. She was thinking that platforms 9 and 10 were in the InterCity part of the station, but they are actually among the rather less grand suburban platforms – she was thinking of the lower-numbered platforms. The movie followed Rowling's original idea by using the platforms she originally thought of.

🎥 *Harvey* James Stewart suggested to the director, Henry Koster, that the framing of many shots should be widened, just to make sure that the large invisible rabbit would be able to fit into shot. His suggestion was followed.

🎥 *Home Alone* The concept for this movie came out of the filming of a scene in *Uncle Buck*. In that film Macaulay Culkin plays a character who interrogates a would-be babysitter through a letter box.

🎥 *I, Robot* The other driver involved in the car crash that ends up with Spooner losing his arm is given as Harold Lloyd. This is also the name of a silent-film star who lost the thumb and forefinger on his right hand when a supposedly prop bomb turned out to be real.

🎥 *Lethal Weapon 2* Leo's oft-recurring line "Okay-okay-okay" is based on the way Disneyland employees gave directions to Fantasyland.

🎥 *The Lost World: Jurassic Park* Steven Spielberg had to attend a preview screening for *Swingers* because it contained a bit of the *Jaws* theme and he had to approve it. On seeing Vince Vaughn's performance he was so impressed that he offered Vaughn a part in this film.

The Man Who Wasn't There Joel and Ethan Coen developed the story for this film while working on *The Hudsucker Proxy*. When they were filming the scene in the barber's, the Coens saw a prop poster of haircuts from the 1940s and began making up a story about the barber who cut the hair shown on the poster.

Manhunter The novel by Thomas Harris is called *Red Dragon*, and the film was originally going to have the same title. However, *Year of the Dragon*, released a year earlier, failed at the box office, so producer Dino De Laurentiis decided to steer clear of any title involving the word "dragon" to avoid audiences associating the two films.

Mars Attacks! Tim Burton was repeatedly told that he wasn't allowed to kill off any character played by Jack Nicholson in a film. Because of that he decided to cast Nicholson as two separate characters in this movie, both of whom get bumped off.

Masters of the Universe The film was largely a disappointment, both commercially and critically. A sequel was written, but by 1989 the He-Man franchise was no longer popular and the script was shot as the action film *Cyborg*.

Minority Report The film was originally intended to be a sequel to *Total Recall*, with Tom Cruise's character played by Arnold Schwarzenegger and the "Precogs" becoming Martian mutants with psychic abilities.

Mission: Impossible When shooting the classic scene with Tom Cruise being lowered from the ceiling and hovering barely above the floor, Cruise's head kept banging against the ground. He eventually got the idea of balancing himself out by putting coins in his shoes.

🎬 *Monty Python and the Holy Grail* Originally, the cast were going to ride horses, but then they realised that they didn't have the budget for it. So they came up with the idea of creating the sound effect by the traditional method of using empty coconut halves banged together. They then decided that it would be a good idea to actually show the coconuts in the film, hence the repeated joke that was never at first meant to be included.

The idea for the killer rabbit came from the façade of Notre Dame cathedral. Near the entrance, one of several panels depicting various scenes of man's infirmities and vices illustrates cowardice by showing a knight recoiling from a rabbit.

🎬 *Never Say Never Again* The title was apparently inspired by Sean Connery's wife. He'd told her before that he'd never play the role of Bond again, then changed his mind for this film.

🎬 *A Nightmare on Elm Street* Wes Craven named Freddy Krueger after a bully who tormented him in school.

Freddy Krueger's clothes were based on those of a homeless man who'd scared Wes Craven as a teenager.

🎬 *Ocean's Twelve* This film originated as a screenplay called *Honour Among Thieves*, which was originally intended to be a John Woo vehicle. After the success of *Ocean's Eleven*, Warner Bros. asked George Nolfi to rewrite his script, adjusting it to incorporate the *Ocean's Eleven* characters, and it turned into the screenplay for this film.

🎬 *Office Space* The red "Swingline" stapler that Milton is so afraid of having taken from him had never to that point actually been manufactured by the company: it was just painted red by a crew member in the props department. However, after the movie's success on video the demand for red staplers increased massively,

apparently due to it becoming a symbol of quiet rebellion among employees stuck in office cubicles. As a result Swingline started to make red staplers in that style.

The People Under the Stairs Wes Craven was inspired to write this film after seeing a real-life news story about some parents who had locked their children up inside their house, never allowing them outside.

Phone Booth The idea of a film whose action takes place entirely inside a phone booth was first pitched to Alfred Hitchcock in the 1960s by the screenwriter Larry Cohen. Hitchcock liked the idea, but neither he nor Cohen could work out a decent reason for keeping the events limited to just one spot. In the late 1990s Cohen realised that a sniper would provide the crucial missing factor, and managed to write the script in less than a month.

When Katie Holmes is in the restaurant, she is taking part in a scene that was actually shot while she was relaxing between takes. Joel Schumacher thought that it fitted the part.

Pulp Fiction The cab driver, Esmeralda Villa Lobos, appeared in a thirty-minute short called *Curdled* in 1991. She played a character who was intrigued by murder and got a job cleaning up after grisly deaths. Tarantino enjoyed the film and decided to include the character in *Pulp Fiction*.

Road To Perdition Jude Law's character, Maguire, was based on Arthur Fellig who photographed bodies at crime and fire scenes, then sold them to the tabloids. The photos shown in Maguire's apartment are real crime-scene photos, and some were taken by Fellig himself.

The Silence of the Lambs Buffalo Bill was based on three real serial killers: Ed Gein, who skinned his victims and wore the

pelt; Ted Bundy, who wore a cast to appear crippled and to lure unsuspecting, sympathetic women; and Gary Heidnik, a man who kept the women he abducted in a pit in his basement.

Speed Director Jan de Bont was the cinematographer for *Die Hard*. A lift in the building in which he was filming got stuck on the fortieth floor. He was in it and had to climb out through the escape hatch and then onto another lift to get out. The experience inspired the opening sequence for *Speed*.

Spy Game The scene where Robert Redford asks Brad Pitt if he knows anybody in a certain block of flats and then, when Pitt tells him that he doesn't, orders him to be up on one of the balconies in five minutes comes straight from a book by a former Mossad agent, Victor Ostrovsky. He describes this as a test which forms part of Mossad training.

Star Wars When George Lucas was mixing the *American Graffiti* soundtrack, he coded the reels of film starting with an "R" and coded the dialogue tapes starting with a "D". Sound designer Walter Murch asked him for Reel 2, Dialogue 2 by saying "R2D2." Lucas liked the way that sounded so much that he integrated it into *Star Wars*.

Swingers The last scene of the movie, where Trent sees a woman who he thinks is making faces at him when she's really looking at her baby, is taken from an actual event that happened to Vince Vaughn at an airport, only it was with a man. (Vaughn was freaked out by it and did not play along as Trent does in the film.)

The movie was written by star Jon Favreau, and is loosely based on the actual experiences that he had when he first moved to LA. He too had just split up with a long-term girlfriend, and was relying on his friends Vince Vaughn and Ron Livingston to keep him cheerful. The characters they play in the film are versions of themselves.

🎥 *Taxi Driver* The monologue in the scene where Travis Bickle talks to himself in the mirror was completely ad libbed by Robert De Niro. The screenplay instruction just said: "Travis looks in the mirror." Martin Scorsese was just out of shot at the time, encouraging De Niro to keep going. However, it's not strictly original speech: it is loosely inspired by an exchange from the 1953 movie *Shane*. Before Shane and Chris Calloway fight they square off thus: "You speaking to me?" "I don't see nobody else standing there."

🎥 *The Terminator* James Cameron was inspired to create *The Terminator* while filming in Europe. The first visual image he had was of a metal skeleton coming out of some flames – the script was pretty much written backwards from that. However, the skeleton would have to have a futuristic design, and Cameron knew that he wouldn't be able to afford the kind of budget for a film set in the future. The time-travelling part of the plot was created as a device to include futuristic elements but set the main narrative in the present day.

🎥 *The Texas Chainsaw Massacre* Leatherface is based on the killer Ed Gein, who in reality wore his victims' faces as masks. He also made some really freaky things from other parts of their bodies, including: a belt made of nipples, chairs with human bones for their legs, a skull top for a soup bowl, etc. The police also found a half-eaten human heart on a plate, and a nude, decapitated and gutted body hanging upside down on a meat-hook in Gein's barn.

🎥 *This is Spinal Tap* The "Stonehenge" sequence was inspired by an incident involving Black Sabbath's stage set in 1983. Black Sabbath's 1983–84 tour, which was in support of their hit album *Born Again*, featured Stonehenge monoliths that ended up so embarrassingly huge that only three of them could fit on the stage, leaving precious little room for the band. They even had a dwarf

actor who'd appear on top of the monoliths at the start of each show.

📽 *The Untouchables* In the initial script, the final gunfight would have had Eliot Ness and George Stone shooting it out with Al Capone's gunmen on a halted train. Director Brian De Palma substituted the gunfight on the steps in Chicago's Union Station after the studio decided that tracking down a 1930s-period train would be too expensive.

📽 *The Whole Nine Yards* Bruce Willis was keen to get Matthew Perry involved in this film. He tried to contact him a few times, not realising that he was on holiday. When he still hadn't heard anything back after a few weeks of trying, Willis left the joking threat, "I will chop off your legs, set fire to your house and watch as you drag your bloody stumps out the door" on Perry's answerphone. Matthew Perry ended up on board, and they liked the line so much that it was included in the film.

📽 *Willow* Part of the two-headed dragon called *Eborsisk* was based on Clint Howard, brother of the director, Ron Howard. Ron often gives Clint a cameo appearance in his films, but as he couldn't find a part for the actual Clint in *Willow* he used the dragon instead.

MUSIC

Music can really make a film, and some famous soundtracks have more behind them than you might think . . .

Air Force One In the scene where Harrison Ford is under the plane fighting with the terrorist, at one point when Ford starts doing some damage the classic seven notes of the Indiana Jones theme from *Raiders of the Lost Ark* can be heard.

A Clockwork Orange In the scene where Alex and his Droogs break into the writer's house, Alex starts to sing "Singing in the Rain". This came about after Stanley Kubrick asked Malcolm McDowell whether he could sing during the scene; McDowell chose that song as it was the only one to which he knew the words, from start to finish.

Ed Wood The only Tim Burton film to date which hasn't had a score written by Danny Elfman. The two had decided to take some time off from each other, but teamed up again for *Mars Attacks!*

Kill Bill: Volume 1 The music played when The Bride prepares to fight Copperhead and Cottonmouth is the theme from the TV series *Ironside*, and was presumably chosen because the series shares a few elements with this film. The first episode of *Ironside* has the main character being shot and left for dead, then coming round only to find that his legs don't work. He then sets out to find the people who have done this to him. The music was also heard in the movie *Five Fingers of Death*, the first kung fu movie available in the US and the one that started the martial arts craze in the West.

The tune that Elle Driver whistles in the hospital is the theme from the movie *Twisted Nerve*.

Licence to Kill When Sanchez is chasing Bond in the trucks and he starts to shoot at Bond with the Uzi, the ricochet noise of the bullets sounds like the James Bond theme tune.

M*A*S*H Director Robert Altman's fourteen-year-old son Mike wrote the lyrics to the song "Suicide Is Painless" and in the end received more money in royalties than his father did for directing the film as the music went on to be used in the very popular TV show spin-off.

Mallrats The music playing while the others are waiting outside the lift in which Brodie and Rene are having sex is the same tune as the lift music from *The Blues Brothers*, "The Girl From Ipanema".

Moonraker The music played on the Venice lab's entry panel is the same as the main theme from Spielberg's *Close Encounters*.

The Witches of Eastwick John Williams, who composed the film's music, provided the whistling that is heard when Jack Nicholson is at the ice-cream counter. It was dubbed in after shooting.

ON-SET EVENTS

Very often things will happen on-set that are noteworthy but which aren't caught on film – or, if they are, they don't really belong in the finished product.

1941 For the scene where the P-40 Tomahawk crashes in the street, the effects guys used a real plane and put it on a long ramp so that it would actually fly into the scene. No one was entirely sure how far it would travel before it came to a stop, so the cast and crew started a pool and placed bets on how far it would go. The day after they shot the scene, some of the crew walked into director Steven Spielberg's office and dumped a huge jar of money onto the desk in front of him. He'd won the pool.

2001: A Space Odyssey The monolith was initially going to be a black tetrahedron. As it turned out, that shape and colour didn't reflect the light properly. Stanley Kubrick decided to change it to a transparent cube, but the opposite was now true: the studio lights produced too many reflections, so that idea was scrapped too. The next design was a rectangular block made from lucite but this was thought not to be convincing enough. Eventually the film-makers settled on the final design used in the film.

25th Hour While filming a fight scene, Barry Pepper accidentally broke Edward Norton's nose.

28 Days Later The crew had filed all the proper requests to permit the destruction of the Canary Wharf petrol station, but due to an oversight the police hadn't been told what was going to happen. When the explosives went off, the police assumed that a petrol station had really exploded and sent the fire services to the site. A fire crew was of course there already, so nothing got out of

hand. But it took a good few hours to get everyone straightened out.

Aliens The character of Hicks was originally going to be played by James Remar, but he was eventually replaced by Michael Biehn due to "artistic differences". However, the scene when the Marines go into the alien nest had already been shot and would have been too expensive to redo, so the back of Hicks seen in that scene actually belongs to James Remar.

James Cameron deliberately left until last the filming of the scene where the Marines are first introduced. That way the good-natured banter between them would be more realistic as the actors would have spent a lot of time filming together already.

During the sequences when Newt is in the air vent, actress Carrie Henn deliberately kept messing up her lines so that she could slide down the vent, which she described as "a slide three storeys tall". James Cameron finally gave in and said that if she got the scene right she could play in it to her heart's content. She did it all perfectly, and he kept his word.

American Graffiti Harrison Ford wears a white cowboy hat in the film because George Lucas wanted him to get his hair cut in the 1950s "crew-cut" fashion. Ford didn't want to because at the time it was in style to have longer hair and he was afraid that it would prejudice future acting jobs if he cut it. He convinced Lucas to just let him wear the hat to cover his hair.

American Pie 2 When Michelle is pretending to break up with Jim so that he can get together with Nadia, her hairstyle is different from how it is in the rest of the film. The actress had been shooting an episode of *Buffy the Vampire Slayer* nearby, and she just ran over to the *American Pie* set when she had sufficient spare time to shoot this scene.

🎥 *Apocalypse Now* Martin Sheen suffered a heart attack while filming in 1976. Sheen's brother Joe Estevez doubled in, as well as providing Willard's voice-over narrations.

🎥 *Backdraft* For this production, six fire engines were completely renovated. After filming was completed, five of them were donated to the Chicago Fire Deparment (the one featured in the film) who used four of them in day-to-day firefighting operations for several years, with one kept as a spare. The engine not donated was the one that is crashed during the film.

🎥 *Bad Taste* Peter Jackson made all the masks for the film in his mother's kitchen. The aliens' heads are all bent backwards because that was the only way he could fit them into the oven to harden the latex used in their production.

🎥 *Batman Begins* Some people wanted the Batmobile to be computer-generated, but director Christopher Nolan refused, so it was built from scratch. It can do 0–60 in six seconds.

🎥 *The Big Lebowski* In the dream sequence where The Dude is floating between the legs of a row of girls and is looking up their skirts, the actresses played a trick on actor Jeff Bridges. Without telling any of the cast or crew, the girls all put wigs under their leotards so that large bits of hair poked out of the sides, which would only be visible from underneath. Jeff Bridges later said, "It was really funny, but I couldn't laugh. But that's why I have that weird smile on my face in the picture."

🎥 *The Birds* Alfred Hitchcock hated working on location so he would use a studio whenever possible. In an early scene of this film Tippi Hedren crosses the road to get to a pet shop. She passes briefly behind a sign, then comes out on the other side. The moment when she's out of shot was used to cut back to a studio.

🎥 **Blade** The first version of the film was test-screened to audiences with disastrous results, forcing a lot of reshoots and significant edits and delaying the release for over six months. The biggest alteration was the final sword fight between Deacon Frost and Blade, which didn't feature in the initial version of the film.

🎥 **Blade Runner** Pris (Daryl Hannah) is doubled by a male stuntperson during her fight with Deckard. A female gymnast was used to start with but the scene was rehearsed so often that by the time of shooting she was too run-down to actually perform. The swap was disguised with lighting and cunning editing.

🎥 **Blade: Trinity** Jessica Biel accidentally destroyed a $300,000 camera when she shot it with an arrow while filming a scene. (She had been told to "aim for the camera".)

🎥 **The Blair Witch Project** In order to provoke friction between the actors, every day the directors reduced the amount of food that they were given.

The actors were given an outline of the fictional "mythology" behind the plot before they began filming, but no actual script. All the dialogue was improvised, and the actors weren't told about most of the events in the film before they happened. Thus nearly every plot development and twist that they experienced came as a surprise to them, forcing them to give genuine reactions.

🎥 **The Blues Brothers** John Landis had to get an "air-unworthiness certificate" from the Federal Aviation Administration before he was allowed to film the car falling out of the sky. The FAA conducted preliminary tests, dropping the vehicle to make sure that it wasn't going to glide in any way (otherwise it could have moved away from its target line and might have hit something).

After making sure that it dropped like a brick, the scene was allowed to go ahead.

The mall that the Blues Brothers drove through is the old Dixie Square mall in Harvey, Illinois. This 800,000-square-foot shopping centre had been abandoned in 1979 and was renovated specially for the chase sequence. Because of the sponsor involved, some shops could be crashed into, and some couldn't.

🎥 *Das Boot* Most of the $15 million budget for this film was spent on the construction of U-boats. Blueprints for the original Type VII-C U-boat were discovered at the Chicago Museum of Science and Industry. The original builders of the submarines were shown the plans and were then commissioned to build their first submarine since the end of the Second World War – a full-size seagoing replica. For filming interior shots a second full-size model was built as well.

🎥 *Braveheart* The Battle of Stirling Bridge was filmed on an open plain, rather than actually by the bridge. A local asked Mel Gibson why that was, and was told, "The bridge got in the way." "Aye," the local answered. "That's what the English found."

🎥 *Brazil* During filming, Terry Gilliam became so stressed that he temporarily lost the use of his legs, which only returned to normal several weeks later.

🎥 *Carry On Camping* Barbara Windsor's bra was snatched from her with the aid of a fishing line. What is not so widely known, however, is that the shot that made it into *Carry On Camping* was, in fact, the second take of that scene. At the first attempt to get Ms Windsor's bra to fly though the air, the bra did not come off as planned and the unfortunate actress was pulled over to land face down in the mud.

🎥 **Casino** As Robert De Niro's character is a chain-smoker, multiple takes could easily have led to constant continuity problems with the length of his cigarettes. However, he managed to avoid such hassles by being sure always to hold his cigarettes the same distance from the lit end, so that they'd never appear to suddenly get shorter or longer.

🎥 **Casino Royale** Despite the long scene in which they play each other at baccarat in the casino, Peter Sellers and Orson Welles were never on set at the same time. There are a number of theories to explain this, ranging from stage fright to the two men's alleged intense hatred of each other.

🎥 **Charlie and the Chocolate Factory** A camera lens worth over half a million dollars was destroyed during filming. It hadn't been properly secured, and it fell into the chocolate while the cameraman was trying to get a shot of a chocolate vat.

🎥 **Citizen Kane** To keep the studio from interfering in production, Orson Welles claimed that the cast and crew were "in rehearsal" for the first few days of shooting, when in reality they were actually doing the filming. It took a good few days before the studio caught on.

🎥 **City of God** To prepare the child for the scene where he is shot in the foot and cries, acting coach Fátima Toledo spent some time with the kid, who had never acted before. She discovered that his biggest fear was of having toothache, so when the time came to film the scene she told him to remember what toothache felt like so that when he was shot in the foot he could pretend that the pain from his toothache had moved to his foot.

🎥 **Clerks** When Randal is on the phone, listing all the porn movies that he wants to order, Jeff Anderson wasn't in the same

room as the actress playing the mother. Anderson refused to read the list of porno titles in front of her (and particularly in front of the child). The reaction shots of the mother were obtained by someone else reading the list to her later.

Clerks was filmed at the convenience store in which Kevin Smith, the director, was working at the time. He was only allowed to film when the shop was closed (i.e. at night) so he had to write an explanation for why the shutters were always down into the script.

Director Kevin Smith and producer Scott Mosier edited the movie in the video store that Randal works in, next to the convenience store.

🎥 *A Clockwork Orange*　When Alex is undergoing aversion therapy, which involves his eyes being clamped open, one of Malcolm McDowell's corneas got scratched and he was temporarily blinded. He also got cracked ribs while filming the "humiliation" stage show, and he almost drowned when his breathing equipment failed when he was held underwater in the trough scene.

🎥 *Conan the Barbarian*　The fake blood used in this film came in concentrated form and was supposed to be mixed with water before it was used. Because of the cold weather at the time of the shoot it was mixed with vodka instead, as a rudimentary antifreeze. An unexpected consequence was that in the scenes where the actors were supposed to spit out blood they would swallow it instead and go back to the special-effects man to get some more.

🎥 *Crash*　Because Vaughan's car becomes increasingly beaten up during the course of the film the production needed six vintage Lincolns. Three were used for driving, one for smashing up, one was cut in half for filming shots in a studio, and one was converted

into a pick-up truck that could have a camera mounted on it so that the cameramen could film point-of-view shots of the driver and passenger.

Dawn of the Dead Due to the film's very limited budget, the film-makers could afford professional stunt drivers but no other stuntmen so make-up artist Tom Savini and his assistant Taso N. Stavrakis volunteered for the job. The two of them are involved in almost every stunt seen in the film, though not all of these went exactly as planned. While doing a dive over the rail of the shopping mall, Savini missed most of the cardboard boxes piled up to cushion his fall. His legs and back hit the ground hard, and he had to work from a golf cart for several days.

Die Hard with a Vengeance The sandwich board that Bruce Willis wore while filming the early scene that is set in Harlem actually read "I hate everyone" – as distinct from the more blatantly racist version that appears in the final film. Computer effects were used to change the sign in post-production, although "I hate everyone" does appear in some TV broadcasts.

Dracula (1931) To accommodate all sorts of viewers, the studio also made a silent version of the film (for cinemas without sound equipment) and a Spanish-language version (to be shown in Latin America). The Spanish version is considered a better film, because it was filmed after the English-language takes each day, so the Spanish director and actors would watch the earlier takes and decide how to improve on them.

E.T. The Extra-Terrestrial When E.T. and Elliott are sick, the physicians working on them are not actors but real doctors. Spielberg wanted genuine medics so that the technical talk would sound right and the scenes would be believable.

El Mariachi For much of the out-of-doors filming Robert Rodriguez was a fair way down the street from the actor playing the Mariachi, so people walking past didn't see anyone operating a camera, just a man walking down the street with a sub-machine gun. Rodriguez would put a sign at the end of the street where he was filming to warn people what was going on – but he wrote it in English so that no one would understand what it meant, enhancing further the realistic reactions of passers-by.

The Elephant Man After John Merrick, the real Elephant Man, died, parts of his body were preserved for the benefit of medical science. Some of his internal organs were kept in jars, while plaster casts were taken of his head, one of his arms and a foot. Unfortunately, the organs were destroyed by German air raids during the Second World War but the casts survived and were kept at the London Hospital. The make-up of John Hurt, who played Merrick in the film, was designed based on those casts.

The Evil Dead When the cast are preparing and listening to the tape there is a bit of smoke in the air. There had been an extended previous scene where they had been smoking pot and joking around. However, they'd used real pot and much of what was shot ended up being unusable as a result.

A Few Good Men In one scene Kendrick (played by Kiefer Sutherland) is conveying Tom Cruise and his group around the military base in a Humvee and drives between two rows of marching soldiers. The Humvee is a very wide vehicle, and Sutherland had some trouble steering it – he actually bumped into the soldiers several times.

A Fish Called Wanda During the robbery Kevin Kline actually shot the sensor with the crossbow himself. It only took two takes.

Freaks The electrical equipment used on the set was so badly grounded that crew members frequently received electric shocks.

Full Metal Jacket Many of the extras in the boot-camp scenes were actually serving members of the British Territorial Army. They were chosen because it was assumed that they would be familiar with drill. However, the British drill practices were so different from the American Marine Corps equivalent that R. Lee Ermey himself had to retrain the British troops to march in US Marine fashion. Ermey said it was twice as much work to retrain them as it would have been to instruct raw recruits.

Gladiator The wounds on Russell Crowe's face after the opening battle scene are real. He got them when his horse was startled and backed with him into some branches. When Maximus is telling Commodus that he intends to return home the stitches in his cheek are clearly visible.

Go The director chose the grocery store that part of the movie was filmed in because of its "run-down, big-city" quality. However, when the movie's producers gave the owner of the supermarket the money for permission to film there, the owner used some of that money to redecorate the store, losing the look that had caught the director's eye in the first place. The director and producers were understandably unhappy about this, so after getting consent from the store they hired a crew to restore the place to how it had looked before!

The Godfather In the scene where Sonny is killed by the men with the tommy-guns, James Caan was very apprehensive about how many explosive squibs he was wearing to simulate bullet hits (147, a record number at that time and potentially very

dangerous). He only agreed to do that scene because he didn't want to lose face in front of the female crew members.

In the study when the family decides that Michael should kill Sollozzo and McClusky, Sonny can be seen playing with a cane. While it's assumed to belong to Don Corleone, the cane actually belonged to Al Pacino. He had injured his leg quite badly while filming Michael's escape from the restaurant after he kills Sollozzo and McClusky.

The cat that Don Corleone is holding in the first scene was a stray that Marlon Brando had found. It purred so loudly that it drowned out the lines from the other characters. They ended up having to re-record their voices.

Goldeneye Perrier paid a fortune for the tank to crash through their cans. After the filming Perrier representatives picked up every single can, crushed or intact, to prevent people getting hold of them and reusing them to sell "false" Perrier.

Gone With the Wind As the burning of Atlanta could only be filmed once, all seven of Hollywood's colour cameras were used to shoot it. The set covered forty acres, and the flames reached a height of five hundred feet. On standby were ten fire engines, fifty firemen from the studio and two hundred other helpers, just in case the fire got out of control. After filming finished, three 5,000-gallon water tanks were used to put out the blaze. The fire was so widespread that people living in nearby Culver City jammed the emergency phone lines, thinking that the MGM studios were burning down.

In 1939 the Hollywood Production Code dictated what was allowed to be shown or spoken on screen. Rhett Butler's classic last line – "Frankly, my dear, I don't give a damn" – was initially banned. A few other options were "Nothing could interest me less", "I just

don't care", "It makes my gorge rise", "My indifference is boundless" and "I don't give a hoot". The producer, David O. Selznick, eventually opted to pay a $5,000 fine and keep the original line.

The Good, the Bad and the Ugly While the camera crew were rigging the bridge that was to be blown up, the supervisor in charge of the detonation – who didn't speak any foreign language – thought that he had been given the order to go ahead and so he proceeded to set off the explosion. Trouble was, the camera crew hadn't finished setting everything up and so it was not filmed at all. According to Clint Eastwood, Sergio Leone was the angriest anyone had ever seen him. As a result, the Spanish army agreed to rebuild the bridge for free and this time it hired an explosives man who spoke the right language. This time they got the shot.

Al Mulock plays a one-armed gunslinger who tries to kill Taco when he is taking a bath. However, Mulock could never remember his lines properly. Eventually, Sergio Leone told him just to count from one to ten in Italian while putting a fierce look on his face. The proper dialogue was then dubbed in later on.

Acid was used to burn the fabric of the bags filled with gold coins, making them rip open more easily when struck with the spade. The acid was kept in a lemonade bottle and Eli Wallach was almost killed after drinking from it, unaware of its real contents. He drank milk to ease the burning, and filmed the scene with a mouth full of sores.

GoodFellas Michael Imperioli, playing Spider, broke a glass that he was holding in his hand and had to be rushed to an emergency room during filming of the scene where his character is killed by Joe Pesci. The doctors saw what appeared to be a real gunshot wound in his chest and they started to try and treat it. When Imperioli explained that the gunshot wound was fake but the wounded hand was real, he was made to wait for three hours.

Martin Scorsese asked Joe Pesci to write and direct the "You think I'm funny?" scene himself.

🎥 *Gosford Park* During group scenes, director Robert Altman used two cameras filming at all times, frequently moving (while keeping out of each other's shot, of course). He did this to encourage the actors to act out the scenes naturally, rather than playing only to one camera.

🎥 *Grease* Olivia Newton-John had to be sewn into her jeans at the start of each day's filming because they were so tight. They were put on her in the morning and she was not allowed to take them off or go to the restroom while they were on, as the crew would have had to waste time sewing them back on.

🎥 *Halloween* The story takes place in autumn but the film was actually shot in spring. So the crew had to buy fake paper leaves, paint them in the right autumn colours, then scatter them around in the areas where they were filming. Because the film's budget was so limited, they would have to gather up all the leaves once a shot was completed to reuse them elsewhere.

🎥 *Harry Potter and the Philosopher's Stone* When it was decided to use Gloucester Cathedral for some of the Hogwarts scenes there was a huge outcry in the media. Protesters wrote sackloads of letters to local newspapers, claiming that the idea was blasphemy, and many of them promised to block the film crew's access to the area. In the end, only one protester turned up.

🎥 *Harry Potter and the Prisoner of Azkaban* Director Alfonso Cuarón had each of the three principal actors write an essay about their characters from a first-person point of view, in order to acquaint himself with them. Emma Watson went a little overboard and wrote a sixteen-page essay, much as Hermione

might have done. Daniel Radcliffe wrote a simple one-page paper, and Rupert Grint never even turned his in – fittingly for Ron.

🎥 *Hero* The scenes on the lake took almost three weeks to shoot because director Yimou Zhang insisted that the lake's surface had to be perfectly flat and mirror-like. Due to the lake's natural currents, these conditions were only available for two hours each day, starting at ten a.m. The film-makers had to get up at five a.m. to allow for five hours of preparation and set-up, making sure that they made the most use of the time they had.

🎥 *Hidalgo* Viggo Mortensen liked the horse that was used in the movie so much that he bought it.

🎥 *A History of Violence* For the sex scene on the stairs, David Cronenberg was worried about the two actors getting hurt on the hard wooden steps. He asked one of the stuntmen whether or not he had any stunt pads spare to soften up the stairs. The stuntman laughed, saying that in the twenty years he had been working in the industry no one had ever thought stunt pads were necessary for a sex scene.

🎥 *Indiana Jones and the Last Crusade* In the scene in the Zeppelin where Indy talks with his father, Harrison Ford and Sean Connery both elected to shoot the scene while wearing no trousers because it was so hot and they didn't want to stop every ten seconds to wipe sweat away.

🎥 *Indiana Jones and the Temple of Doom* The rope bridge used during the final fight scene was no special effect – it was built for the film by British engineers who were constructing a dam nearby. Steven Spielberg refused to cross it, so he had to drive for over a mile to get to the other side. The majority of the shots involving the bridge are done from only a third of the way across

for the same reason of caution – even the Steadicam operator didn't want to stand in the middle of it.

🎥 **_The Italian Job_** (1969) Michael Caine couldn't actually drive at the time when the film was made – he is never seen driving a car. The one time in the film that it looks as though Charlie Croker is driving is between when he collects his Aston Martin at the garage and when we see it arrive outside a hotel. However, we don't see him at the wheel – Michael Caine gets out of the Aston Martin when it has already stopped. On every other occasion, including the trip to Turin and the gold heist itself, he is always a passenger.

🎥 **_Jaws_** The shark in the film was nicknamed "Bruce" after Spielberg's lawyer.

The mechanical shark was broken down for a lot of the movie, and couldn't be used for certain shots. This forced Steven Spielberg to use the camera for the shark's point of view, instead of actually seeing the creature. As it turned out, that made the film scarier than it would have been if the shark had been seen as often as was originally scripted.

🎥 **_Jay and Silent Bob Strike Back_** During filming, Kevin Smith accidentally mispronounced Eliza Dushku's last name and subsequently simply called her "Duck Shoot".

🎥 **_Jurassic Park_** The helicopter landing pad had to be brought in by helicopter because the film crew were unable to get trucks into the location.

🎥 **_The Last Samurai_** While Hiroyuki Sanada was filming a battle sequence with Tom Cruise a "live" sword was used. The mechanical-horse prop in the sequence broke and Cruise did not

fall off as planned. The sword came within an inch of Cruise's neck. At the time, bystanders and crew screamed, almost witnessing the actor's decapitation.

🎥 **Leon** Towards the end of the film when a lot of police cars were on the street, a man raced past during filming, fleeing from a shop that he had just robbed. When he ran onto the movie set by accident, he saw all the "police" and surrendered himself to a bunch of uniformed extras.

🎥 **The Living Daylights** The rocket fired out of the ghetto blaster in Q's lab was actually activated off screen by Prince Charles, who was on a tour of the studio at the time of filming. The effects crew offered him the opportunity to fire the rocket in a take that ended up being used in the final cut of the film.

🎥 **Lord of the Rings: The Fellowship of the Ring** In the scene where Merry and Pippin light the firework, Billy Boyd was so shocked by the firework going off when it was being filmed that he actually let out the high-pitched shriek that is heard when the tent goes up. In some of the behind-the-scenes stuff, Dominic Monaghan makes fun of Billy by calling him "a slightly feminine character", while poor Billy tries to defend himself.

🎥 **Lord of the Rings: The Two Towers** While filming the scene where Aragorn is floating unconscious down the river, Viggo Mortensen almost drowned because the rapids were fiercer than expected.

One of the most accomplished horseback riders of the Fellowship, Viggo Mortensen (who loves and owns horses) was allocated a horse who tended to kick into reverse gear in busy shots. As a result, a lot of film was wasted reshooting scenes in which Aragorn backed right into the crowd he was trying to escape from.

🎥 *The Lost Boys* Kiefer Sutherland was originally only meant to wear his black biker gloves during scenes in which he rode his motorbike. However, while messing around off camera, he fell off one of the bikes and broke his arm. He then had to wear the gloves to cover his cast.

🎥 *Love, Actually* The short interchange between Colin and the caterer at Peter and Juliet's wedding was originally a scene that was cut from the final version of *Four Weddings and a Funeral*. Richard Curtis liked the dialogue so much that he used it in *Love, Actually*.

🎥 *Mad Max* The van that is destroyed during the Nightrider chase belonged to director George Miller. This was the last scene to be filmed and the production was out of money. The film-makers couldn't afford another sacrificial vehicle, so Miller used his own.

🎥 *Mad Max 2* For some reason the film-makers thought that it would be fitting for Max to have a dog. They "interviewed" over a hundred dogs and were not satisfied with any of them, so they scrapped the idea. Just by chance, the director was visiting a friend's farm and met the dog who's in the movie – the dog was so intelligent and willing to follow commands that George Miller felt he just had to have him. Unfortunately, on the first day of shooting the dog started behaving very strangely and wouldn't listen to instructions. The movie people almost scrapped the dog idea again, until one of the film crew found out that the sound of roaring engines was what was bothering the mutt. They plugged his ears with cotton, which can just about be seen in some shots, and the dog began behaving properly again.

🎥 *Magnum Force* Harry Callahan is threatened by the vigilante motorcycle cops in a garage. Immediately after that scene, the motorbikes ride off – and in real life every single one of them

crashed. Clint Eastwood said later that it was as if he'd been threatened by the Keystone Kops.

🎥 *Mallrats* Shannen Doherty changes her outfit regularly throughout the film. Apparently this is because in her contract it said that she got to keep any clothes that she wore during shooting, so she changed them as often as possible.

🎥 *The Manchurian Candidate* Frank Sinatra broke one of his fingers when he hit the table – a real one, not an easily smashed prop – in the fight sequence with Henry Silva. Because he had other filming projects, he wasn't able to rest or bandage his hand properly, which meant that the injury never healed properly. It caused him severe discomfort for the rest of his life.

🎥 *Manhunter* In the final confrontation between Dollarhyde and Graham, Tom Noonan had to lie in a pool of stage blood for several hours while the crew worked on other shots. After all that time the stage blood dried into a thick, cement-like adhesive that all but fused Noonan to the carpet. A similar thing later happened to Tim Roth while he was acting in *Reservoir Dogs*.

🎥 *Mars Attacks!* The dress worn by Lisa Marie in her role as the "Martian Girl" had no zips or buttons in order to make its surface as smooth as possible. This meant that every day she had to be sewn into it.

🎥 *The Matrix Reloaded* One night on the two-mile stretch of freeway built for this movie a security guard decided to race his car up and down when no one was around. He totalled his car and instead of telling anyone he just ran off and was never seen again.

Keanu Reeves bought Harley Davidsons for all the stuntmen involved in the "Burly Brawl" where he fights multiple Agent Smiths.

The Mummy Returns Extra cliffs had to be added digitally to the tidal-wave sandstorm scene, as hundreds of spectators had been watching the filming and would have been clearly visible on screen.

This movie marked the first time that Tower Bridge, an incredibly busy Thames crossing, had ever been closed for filming. The film-makers were allowed to close it for twenty minutes at a time, but the first closure caused such a massive traffic jam that they were threatened with arrest. All subsequent filming sessions at this location were limited to ten minutes.

Natural Born Killers During filming, Juliette Lewis accidentally broke Tom Sizemore's nose when she slammed his face into the wall during a fight scene.

To maintain a frantic mood during filming, loud raucous music would be played on the set, and the crew would fire shotguns into the air.

Never Say Never Again Kevin McClory, who co-wrote and co-produced *Thunderball* (of which *Never Say Never Again* is a remake), won the right to produce this film following a legal battle with the Ian Fleming estate. Because the film was produced outside the auspices of the Fleming estate, Albert Broccoli and MGM/UA, it is not considered part of the "official" Bond series. McClory wanted to do another remake, called *Warhead 2001*, using the same elements to which he had rights but all rights were eventually returned to MGM.

Night of the Living Dead The scene where Barbara crashes the car into the tree wasn't scripted originally; an accident that put a large dent in the car before the scene was shot prompted George Romero to rewrite it in such a way that the dent is explained.

Nixon When shooting the scene where Nixon and Jones confront each other, the studio lights were pointed straight down, directly onto coffee tables which were in front of the fur-upholstered couch. The lights were so strong that the rug under one of the tables actually started smoking. Part-way through a take, one of the extras noticed the smoke and quietly muttered "Fire" during a gap in the dialogue. Fortunately James Woods heard this and the scene was stopped before the rug caught alight.

Ocean's Twelve Both Brad Pitt and George Clooney are notorious pranksters on set. Before filming began Brad Pitt put out a memo to all crew members stating that they must only address George Clooney by his character's name, either "Danny Ocean" or "Mr Ocean". Eventually Clooney worked out why everyone was behaving weirdly around him, and he got his revenge on Pitt by putting bumper stickers on the back of Pitt's car that read "I'm gay and I vote" and "Small penis on board".

The Omen This film seemed to fall under a sinister curse soon after it changed its title from *The Antichrist* to *The Birthmark*. Star Gregory Peck and screenwriter David Seltzer flew on separate planes to the UK, and lightning struck both aircraft. Producer Harvey Bernard was almost struck by lightning while in Rome. Rottweilers that had been hired for the film attacked their trainers. Director Richard Donner was staying at a hotel that got bombed by the IRA, and he also got hit by a car. Gregory Peck was due to fly to Israel, but cancelled. The plane that he would have chartered crashed, killing all on board. On the first day of the shoot, several principal members of the crew were in a head-on car crash but they survived.

Panic Room Because Nicole Kidman was originally cast in Jodie Foster's role, the sets had been designed based on her height. Normally that wouldn't be a problem, except that in this case the

green light on the panic-room door (the blockage sensor) was right at Jodie Foster's eye level, dazzling her every time she went through the door.

The Passion of the Christ Jim Caviezel was struck by lightning while filming the Sermon On the Mount scene. He was also accidentally whipped on the back for real and since the crew were filming at the time his genuine reactions were incorporated for his role on screen. The whipping left him with a fourteen-inch scar.

Phone Booth The phone that Colin Farrell was hooked up to actually had a person at the other end of the line talking to him, to keep him sane during the confining shoot.

Plan 9 from Outer Space All two minutes of Bela Lugosi's footage for this movie was shot just before he died – and before there was actually a script. Edward D. Wood Jr then based the plot on the footage that he already had. Because Lugosi was now dead Wood used his wife's chiropractor as a "double" although the man was noticeably taller than Lugosi. All the chiropractor's scenes were shot with a cape covering his face.

The Poseidon Adventure The look of the set for the upside-down engine room was so realistic that the actors refused to climb anything, fearing that it would topple over. The set designer and builders had to climb everything first to prove that it would hold.

Predator 2 The plot of *Predator 2* underwent a few changes in its earliest stages. The role of Gary Busey's character "Keyes" was actually intended to be "Dutch", Arnold Schwarzenegger's character from the first film. Schwarzenegger was very outspoken in his criticism of the script of *Predator 2*, feeling that taking the action into the city was a bad idea. He declined to fill the role. Hence

Peter Keyes was created. Schwarzenegger was approached once more, this time to be Keyes's assistant (a role eventually played by Adam Baldwin), but his response was the same: no way.

🎥 **The Princess Bride** André the Giant had back problems during filming (ironically, given that his character is incredibly strong). These prevented him from being able to lift anything heavy, so Robin Wright Penn had to be hooked up to wires in the scene where Buttercup jumps out of the castle window into Fezzik's arms, as he couldn't hold her himself.

When Count Rugen hits Westley over the head, Cary Elwes told Christopher Guest to actually hit him. Guest hit him so hard that production had to be shut down for a day so Cary Elwes could go to hospital.

When Robin Wright Penn's dress catches fire in one of the flame-burst scenes in the forest, William Goldman, the writer, was on set that day. He didn't know this was meant to happen so he shouted, "Her dress is on fire!" and ruined the take.

🎥 **Raiders of the Lost Ark** The scene where Indy shoots the sword-wielding bad guy wasn't in the original script. Three months' filming had given Harrison Ford a nasty case of dysentery, and the originally choreographed fight (Indy's whip against the bad guy's sword) would have taken three and a half days to shoot. Ford really didn't want to stay on set that long, so he and Steven Spielberg tried to think of a way to end the fight sooner. Someone said that the only way to finish it quickly would be for Indy to just pull out his gun and shoot the swordsman – crew members nearby immediately burst out laughing at the idea, so that's what ended up being used.

The film-makers discovered to their chagrin that the snakes used for the Well of Souls sequence weren't afraid of fire at all – in fact,

they would always try to get closer to the fire to warm themselves. At one point director Spielberg was caught on camera picking up a snake and telling it, face to face, "In the script, you're supposed to hate fire. Why do you like fire? You're ruining my movie."

The Rocky Horror Picture Show The reason why Dr Scott crashes through the wall of the lab is because the film-makers forgot to add a door to the room when constructing the set.

Saving Private Ryan The resentment that the soldiers feel towards Pvt. Ryan is real: Matt Damon was the only cast member who didn't have to go through boot camp, a deliberate ploy by the film-makers to provoke precisely that reaction from the other actors.

Saw Director and writer James Wan and Leigh Whannell shot a demo scene to present to Hollywood producers in order to get backing for the film. The segment they used was also seen (in an improved version) in the final film – the "reverse bear-trap" scene, with Whannell in place of Shawnee Smith. To make the trap, Wan enlisted the help of a friend who was an industrial designer – the trap actually worked, and if triggered properly could have ripped someone's jaw off. He then rusted the completed trap by soaking it in salt water before leaving it on the roof of his home for a week. He then had to put the trap in his mouth for filming. The trap worn by Shawnee Smith in the actual film was professionally made, with the rusty look painted on.

Scarface Steven Spielberg helped to direct one shot when he was visiting the set. In the final shoot-out at Tony's mansion, Spielberg's contribution is a brief shot of the Bolivians.

Se7en The reason why Brad Pitt gets his arm in a sling is because while the rainy scene where he chases John Doe was being filmed he actually fell against a car, putting his hand through the

windscreen and badly cutting himself. The injury had to be written into the film. Pitt has said in interviews that he's really disappointed the cameras didn't catch the accident.

🎥 **The Shawshank Redemption** The Humane Society had to be present for the scene where the maggot is fed to the bird, Jake. The Society said this was cruel to the maggot, so they had to find one that had died of natural causes before the crew could shoot the scene.

🎥 **The Shining** Initially, the bathroom door that Jack Nicholson axes his way through was an extremely thin one, made that way by the prop department so that it would be easier to destroy. However, Nicholson's technique with the axe was so good (he'd been a volunteer fire marshall) that the door was destroyed almost immediately. So the props guys had to build a much stronger one that could better resist his battering of it.

🎥 **Shivers** Susan Petrie was unable to cry, so David Cronenberg arranged for her to generate some tears by using onions. This worked initially, but the camera was out of focus when the scene was first shot, and then Cronenberg ran out of onions. So Petrie allowed Cronenberg to slap her on the face. He duly did so until her face was numb from multiple takes and slaps. Cronenberg finally had to settle for a series of takes that he wasn't particularly happy with.

🎥 **Sideways** Most of the wine drunk by the actors in the wine-tasting scenes was non-alcoholic. They ended up drinking so much of it that it made them feel ill, and they had to switch to the real thing every so often to cleanse their palates.

🎥 **Some Like It Hot** Marilyn Monroe needed forty-seven takes to get the line "It's me, sugar" right. She frequently said either

"Sugar, it's me" or "It's sugar, me." After take thirty, Billy Wilder resorted to having the line written on a blackboard. Another scene required Monroe to search through some drawers and ask, "Where's the bourbon?" Forty takes later she'd only been able to come up with various permutations such as "Where's the whiskey?", "Where's the bottle?" or "Where's the bonbon?" So Wilder stuck the correct line in one of the drawers. Marilyn Monroe then ended up confused about which drawer actually contained the line, so Wilder had it put into every drawer. The scene ended up needing fifty-nine takes, and when Monroe finally does deliver the line on film she has her back to the camera so that her lips cannot be seen. This has led some people to wonder if Wilder finally just gave up and had the line dubbed in later.

🎥 *The Spy Who Loved Me* Jaws's "teeth" were so painful that actor Richard Kiel could only keep them in for a few seconds at a time, which is why there are not too many long shots with them visible. He only wore them when the script required him to open his mouth.

Due to his failing eyesight, cinematographer Claude Renoir was unable to see to the end of the enormous supertanker set, forcing production designer Ken Adam to ask his friend Stanley Kubrick to supervise lighting for the set. Kubrick agreed on condition that his involvement was kept totally secret.

🎥 *Star Wars* George Lucas insisted on moving all the credits to the end of the movie to preserve the dramatic opening of the film and not intrude on the iconic opening crawl. The Directors' Guild of America took issue with this, and demanded that Lucas follow Guild regulations and put the credits at the beginning, or face a fine. He decided to keep things as he wanted them to be, paid the fine and, as soon as *Star Wars* was released, resigned from the Guild.

🎥 **Straw Dogs** When Dustin Hoffman's character beats a man on the floor to death, Hoffman wanted to have something physically there for him to smash up, in order to convey the disturbing pleasure he's taking in what he's doing. As a result some coconuts were put on the floor for him to destroy – in one shot a bit of smashed coconut is actually visible, but director Sam Peckinpah simply said that it was brain matter.

🎥 **Superman** Marlon Brando refused to learn most of his lines in advance. In the scene where he puts the infant Kal-El into the escape pod he was actually reading his lines from the baby's nappy.

🎥 **Terminator 2: Judgment Day** After the chase featuring the heroes on the bike and the bad guy in the truck, the truck finally crashes and explodes. The Terminator then aims his Winchester, waiting for the T-1000 to appear. But the T-1000 does not emerge from the fire and the Terminator lowers the gun without looking. The Winchester passes so close to John Sonnor's head that it brushes his hair. In another take, he actually got hit on the head by Arnie.

The top of the truck was not originally going to be ripped off during the chase down the storm drain, but when the crew arrived at the location they discovered that the cab wouldn't fit under the overpass. Director James Cameron realised that the only way to film the scene would be to get the roof off.

Edward Furlong had to re-record most of his dialogue in post-production because his voice was breaking during shooting. His "young" voice is only heard in the scene where he and Arnold Schwarzenegger are discussing why people cry – James Cameron thought it sounded more dramatic in the original take.

🎥 **The Terminator** The body bag that Reese is zipped into at the end of the film is actually a suit bag that belonged to director

James Cameron. A pick-up shot was needed and Cameron happened to have the bag in his car, so he pulled it out and, presto, instant body bag.

The Texas Chainsaw Massacre The scene where Leatherface kills the first of the teenagers had to be reshot several times because Gunnar Hansen kept apologising to the actor concerned after he'd hit him.

Tomorrow Never Dies In the scene where Q delivers Bond's new car, he was originally going to open a box containing a live jaguar and says, "Wrong crate." Although the scene was deleted from the final cut, the crate with the jaguar is still in the background.

Top Gun The scene where Maverick makes love to Charlie was shot in the dark for a specific reason. When they reviewed the movie after it was originally finished, the producers and marketing people felt that it needed a love scene. Unfortunately, Kelly McGillis (Charlie) was doing another movie in which she had red hair. In shooting the scene, the darkness was used to subtly conceal the fact that her hair is no longer blonde. Any romantic effect is incidental.

Tron Director Steven Lisberger had several arcade games scattered around the sets. The cast and crew often had to be called away from them to return to shooting, particularly Jeff Bridges who would often claim that he was "preparing for the next scene" in order to keep playing a bit longer.

Troy Brad Pitt and Eric Bana both performed their own fight scenes. They had an agreement that for every blow they accidentally landed on each other, they would pay the other actor $50 for a relatively light hit and $100 for a hard one. Brad Pitt ended

up having to pay $750 to Eric Bana, who never owed Brad Pitt anything.

Twelve Monkeys Terry Gilliam wasn't sure that Brad Pitt would be able to perform in the nervous, rapid-talking way that his character had to. He initially sent him to a speech coach, but in the end he realised that it would be easier just to take the actor's cigarettes away. Unable to smoke, Pitt played the part perfectly.

Walking Tall At one point The Rock smashes the rear light of a Porsche. Unfortunately, he wasn't supposed to do that to the actual Porsche – something he realised only when the crew went completely silent after he'd done it. Realising his mistake, he asked, "Did we just buy this car?" The director quickly checked with someone: "Yes."

Willy Wonka & the Chocolate Factory For the car-wash scene, the foam used was the same as that used in standard fire extinguishers. Unfortunately, the cast and crew didn't realise that this foam is extremely unkind to skin, so soon after shooting finished the actors were in considerable discomfort because of skin irritation and swelling. They needed several days off in order to get medical treatment and recover.

Withnail & I Withnail is a ferocious drunk, but the actor who played him, Richard E. Grant, is a teetotaller. He decided that he needed to get drunk at least once to get a proper insight into the character, so he "filled a tumbler with vodka and topped it off with a bit of Pepsi", then downed the whole thing in one. The next day co-star Paul McGann and director Bruce Robinson good-naturedly teased him, saying that he'd never be that funny again.

ORIGINALLY CONSIDERED

Your favourite movies, your favourite actors – they may seem as if they were always destined to be together and it couldn't be any other way. But unfortunately that's just not the case. Surprisingly often it very nearly went in another direction ...

Amélie The part of Amélie was originally intended for Emily Watson. While she was keen for the part, she had to turn it down as she didn't speak French and was already committed to acting in *Gosford Park*.

Animal House Dan Aykroyd was supposed to play D-Day, but he couldn't get out of his *Saturday Night Live* contract. The character of D-Day was actually based on what Dan Aykroyd was like in college.

Apocalypse Now The role of Captain Willard was first offered to Steve McQueen, who turned it down. Harvey Keitel was then cast in the part, but two weeks into shooting he was replaced with Martin Sheen, due to creative differences with director Francis Ford Coppola.

Back to the Future Eric Stoltz was originally cast as Marty. After filming quite a few scenes they realised that he wasn't quite right for the role, so they cast Michael J. Fox instead, who was contracted to the TV show *Family Ties* at the time. Fox would drive straight to the movie set every day after taping of the show was finished, averaging about one or two hours' sleep a night. Most of the filming was done between six p.m. and six a.m., with any daylight scenes being filmed at weekends.

Basic Instinct Before Sharon Stone was cast as Catherine, Michelle Pfeiffer, Julia Roberts, Kim Basinger, Kelly McGillis, Greta

Scacchi, Emma Thompson and Mariel Hemingway all turned down the role.

🎥 **Batman** Sean Young was cast as Vicki Vale first, but while filming a horse-riding scene with Michael Keaton she fell and broke her collarbone. When filming resumed with Kim Basinger the scene wasn't included.

Joel and Ethan Coen were offered the chance to direct first but declined. Tim Burton was then given the job.

Tim Burton's first choice for The Joker was apparently Ray Liotta. Failing that, Burton had him in mind for the part of Harvey Dent (under the assumption that in a later film he'd be perfect to play Two-Face). Unfortunately Liotta had to turn down both parts as he was committed to *GoodFellas*.

🎥 **Batman Returns** Annette Bening was originally cast as Catwoman but she became pregnant and so was replaced by Michelle Pfeiffer.

🎥 **Boogie Nights** Leonardo DiCaprio was originally offered the role of Dirk Diggler. Despite liking the script, he had already signed up to *Titanic*. However, he suggested that Mark Wahlberg might be good for the part.

🎥 **Charlie and the Chocolate Factory** Christopher Walken, Steve Martin, Nicolas Cage, Robin Williams, Will Smith, Brad Pitt, Michael Keaton, Jim Carrey and Adam Sandler were all considered for the role of Willy Wonka. Marilyn Manson was also keen for the part.

🎥 **Dogma** Emma Thompson was originally cast to play God, but she had to pull out before filming started to have a baby. She was replaced by Alanis Morissette.

Dr No Author Ian Fleming originally asked Noel Coward to play the part of Dr No. Coward replied in a telegram: "Dr No? No. No. No."

Ghostbusters Writer Dan Aykroyd originally wrote the role of Venkman for John Belushi, but approached Bill Murray after Belushi's death. John Belushi still appears in the movie in a way – the body movements of the Slimer Ghost were based on his.

Gladiator Mel Gibson was offered the part of Maximus first, but turned it down.

The Godfather Jack Nicholson, Warren Beatty and Dustin Hoffman were all offered the part of Michael Corleone before Al PAcino, but they all turned it down.

Heathers The part of Heather McNamara was originally offered to Heather Graham, who was only seventeen at the time. Her parents decided not to let her do the role because the subject matter was so dark.

The Hunt for Red October The part of Jack Ryan was originally going to be played by Kevin Costner.

JFK Mel Gibson and Harrison Ford were originally offered the role of Jim Garrison before it was taken by Kevin Costner.

Platoon The part of Chris was originally offered to Kyle MacLachlan and then to Keanu Reeves, both of whom turned it down. Charlie Sheen was also turned down initially, as he was thought to be too young. His older brother, Emilio Estevez, was offered the role instead. But then, due to financial problems, the film was put on hold. Two years later it was started up again – by

this time Emilio Estevez was committed to other films, so Charlie Sheen auditioned again and this time he got the part.

🎥 *Predator* Jean-Claude Van Damme was originally cast as The Predator. He quit very early on because he didn't like being uncredited, so the first design was scrapped and remade as what we know and love today.

🎥 *Primal Fear* The part of Aaron Stampler was originally written for Leonardo DiCaprio. He turned the role down and it was given to Edward Norton, his first film role.

🎥 *Raiders of the Lost Ark* The role of Indiana Jones was initially offered to Tom Selleck, who couldn't do it due to his commitment to *Magnum P.I.* Harrison Ford was their second choice.

🎥 *Signs* Mark Ruffalo was originally cast as Merrill but had to withdraw due to illness. He was replaced by Joaquin Phoenix one week before filming began.

🎥 *Terminator 2: Judgment Day* Michael Biehn, who played Reese in the first film, was the original choice to play the T-1000. The figuring was that it would be a good reversal of roles with Arnold Schwarzenegger, and would make sense, given that Sarah Connor might be inclined to trust him. However, it was eventually decided that audiences would be too confused, and the idea was scrapped.

🎥 *Thelma and Louise* George Clooney auditioned for Ridley Scott five times for the part of JD. It was eventually given to Brad Pitt.

🎥 *The Untouchables* Mel Gibson and Harrison Ford both declined the role of Eliot Ness before Kevin Costner was signed on.

The Wild Bunch The role of Pike Bishop was offered to but turned down by Burt Lancaster, Charlton Heston, James Stewart, Sterling Hayden, Richard Boone, Gregory Peck, Lee Marvin and Robert Mitchum before William Holden was finally cast.

X-Men Dougray Scott was the first to be cast to play Wolverine, but had to step down because filming on *Mission: Impossible II* overran.

PIONEERS

TAKE 17

Certain film-makers and cinematic events were so significant and groundbreaking that they changed the way films work for ever ...

The Charge of the Light Brigade Over two hundred horses were killed during filming. Because of this, the US Congress passed laws to protect any animals used in films.

Citizen Kane This film originated the use of "deep focus" – a filming method developed by Orson Welles and cinematographer Gregg Toland that can keep every object in focus simultaneously, whether it's in the foreground, centre or background of a shot.

Rashomon Parts of the forest in which the crew wanted to shoot were too dark for the cameras even at high noon. A regular foil reflector failed to "bounce" enough light, so director Akira Kurosawa and cinematographer Kazuo Miyagawa decided instead to use a full-length mirror, which they "borrowed" from the studio's costume department. With this mirror the crew bounced light through leaves and branches to soften it, forgoing any artificial techniques. Miyagawa later described it as the most successful lighting effect he had ever done.

Rollerball This was the first film to give full screen credits to the stuntmen. Normally they wouldn't have received a credit for any work they did, but the director was so impressed by their achievements that he felt moved to include their names in the closing credits. Stunt performers have received proper credit for their work ever since.

Regrettably, not everything is instantly categorisable . . .

2001: A Space Odyssey As HAL loses his mind, he begins to sing "Daisy" (the official title of which is actually "A Bicycle Built for Two"). In 1961, this was the first song ever to be reproduced with a nonhuman voice – a computer's.

If you take the letters in the computer's name (HAL), and then the next letter in the alphabet after each one, you get IBM. Arthur C. Clarke insists that this was entirely accidental, but by the time he noticed it was too late to change it.

Originally, the astronauts were supposed to head for Saturn but Stanley Kubrick found creating the effects for the rings would be too costly. So he selected Jupiter instead.

Adaptation When this film was nominated for Best Adapted Screenplay at the 75th Academy Awards, the fictitious Donald Kaufman was named as screenwriter. This was the first time an Academy Award nomination was given to someone who didn't actually exist. The Academy made it clear that if they won the two Kaufman brothers would have to share the same statue.

Air Force One One of the secretaries tells the American president that she can send a fax to the White House, and he replies along the lines of: "If this works, I'll make you Postmaster General." In the closing credits, the actress concerned is credited simply as "Future Postmaster General".

Alien It was rumoured for a while that no one knew what was going to happen during the famous chest-bursting scene, when the alien erupts from John Hurt. This isn't entirely true – the

cast knew that the alien was going to appear – but specifics were kept deliberately vague. For example, the amount of blood sprayed everywhere certainly wasn't expected.

Alien³ The original concept for the film, which was green-lighted by the studio, was set on a man-made wooden "planet", inhabited by a group of monks who were living a Middle Ages lifestyle, shunning any and all modern technology. When Ripley and the alien crash-land the monks would blame Ripley for bringing destruction down on them. The designer, Vincent Ward, abandoned the project after the producers insisted that the elaborate concept should be scaled down to a prison planet.

Alien Resurrection The director, Jean-Pierre Jeunet, was keen to demonstrate that Ripley had acidic blood like the aliens by showing a mosquito stinging her, then disintegrating after ingesting her blood. When the effects team worked out how much it would cost the idea was ditched.

Aliens One of the sets for *Aliens* was later reused as the Axis Chemical plant in *Batman*. When the crew for *Batman* first came to the set to start making alterations, most of the alien nest was still there in one piece.

The woman who plays Vasquez (Jenette Goldstein) is the same actress who plays John Connor's foster mother in *Terminator 2*. It's amazing what they can do with make-up. James Cameron, like many directors, likes to use the same actors in different films. She is also in *Titanic*, where she plays the mother of the two kids in the belly of the ship who tells them a bedtime story before the water starts coming in.

With the exception of Hicks, who is given a first name (Dwayne) in the script, the marines all have the same first initial as the actors who portray them (you can see the initials next to their surnames

in the corner of their eye cameras). Note, of course, that "Bill" (as in Paxton) is short for William. This includes Ferro, whose first initial is given as C (matching the actress Colette Hiller) – Vasquez appears to call Ferro "Mira" at one point when asking who Ripley is. "Mira" is Spanish for "look" – she is simply drawing Ferro's attention to Ripley.

Apocalypse Now Laurence Fishburne (who played Tyrone "Clean" Miller) lied about his age to get cast. He was fourteen when production started, but told director Francis Ford Coppola that he was seventeen.

Apollo 13 The actual words spoken by Jim Lovell when the spacecraft got damaged were actually "Houston, we've had a problem."

Army of Darkness Contrary to popular belief, the items we see in Ash's car (the *Fangoria* magazine, the Coca-Cola bottle, etc.) are not product placements. Sam Raimi actually had all that stuff in the trunk when the car was brought in for filming and never bothered to clean it out.

Back to the Future When Marty's stranded in 1955, on the day of the dance, there are actually four Deloreans present that afternoon: the Delorean that Marty originally drove, the Delorean that Biff stole from 2015 and returned in to give his younger self the almanac, the Delorean that Doc and Marty returned in to take the almanac back, and the Delorean buried in the mine, which Doc put there in 1885.

Back to the Future Part III Mad Dog Tannen was originally going to kill Marshal Strickland by shooting him in the back, while his son was there. This was decided to be too depressing, so it was taken out of the final cut of the film. However, it does explain why

it's the deputy marshal who arrests Mad Dog at the end, rather than Strickland.

🎥 **Bad Boys II** The mansion that is blown up at the end of the film was an actual mansion in Delray Beach, in Florida. The person who bought the property didn't want the house, only the land it was on. They offered its use to any production company that would blow the building up and pay to clear the land afterwards.

🎥 **Batman** The Joker's surname, Napier, was created for this film. It has two origins – first, a tribute to Alan Napier, the actor who played Alfred in the *Batman* TV series, who died shortly before the film began production. And The Joker's full name, Jack Napier, is also a deliberate pun on the word "jackanapes" which can be defined as an impudent person, or a mischievous child.

🎥 **The Beach** The beach is in reality not hidden from the sea by being totally surrounded and enclosed by mountains. The real location actually has a large gap between two huge rocks, and a fake mountain had to be digitally added in post-production.

🎥 **Being John Malkovich** Craig realises that LesterCorp is on the 7½th floor of the Mertin Flemmer building when he sees "7½" listed on the building directory, 7½ minutes into the film.

🎥 **The Big Lebowski** Throughout the whole movie The Dude is not seen bowling once. Also, every time Donnie (Steve Buscemi) bowls, he gets a strike, except for in the last bowling scene when he does not and dies of a heart attack a few minutes later.

🎥 **The Blues Brothers** At one time this movie was in *The Guinness Book of Records* for destroying the most cars in a single movie. This record was then beaten by *Blues Brothers 2000*.

🎥 *Bound* The Wachowski brothers were offered this film as a trial run for making *The Matrix*. They'd come up with the idea for that film while their first script (*Assassins*) was filming, but the studio was loath to give two inexperienced film-makers such an enormous project. *Bound* was made to see how they handled it – it was a success, so *The Matrix* was given the go-ahead.

🎥 *The Bourne Supremacy* When Bourne calls Pamela Landy from the rooftop, we can hear a voice in her office saying that they "need ninety seconds to triangulate his position". Exactly eighty-eight seconds later, Bourne hangs up.

🎥 *Butch Cassidy and The Sundance Kid* The real name of Butch Cassidy's gang was The Wild Bunch. The name in the film was changed to The Hole-in-the-Wall Gang, to avoid any confusion with the Sam Peckinpah film *The Wild Bunch*, which was released only a few months earlier.

🎥 *The Cannonball Run* The ambulance used in the film is the real ambulance that director Hal Needham and writer Brock Yates built and raced in the real Cannonball Run.

🎥 *Cast Away* Production was shut down for a year to give Tom Hanks enough time to lose weight and grow his "castaway" beard. During that time, director Robert Zemeckis used the same crew members to help film *What Lies Beneath*.

Robert Zemeckis was asked in an interview if the contents of the unopened package were ever specified. He claimed that it contained a waterproof solar-powered satellite phone.

🎥 *Charlie and the Chocolate Factory* Composer Danny Elfman provided the singing voice of all the Oompa-Loompas. He overdubbed himself many times to give the impression of multiple singers.

Child's Play Chucky's real name is Charles Lee Ray, which is derived from three well-known real-life killers – Charles Manson, Lee Harvey Oswald and James Earl Ray.

City of God Despite the title the film was not shot in the actual "City of God" as the location was too dangerous. It was filmed in a nearby area that was less hazardous.

Clerks In a first for a feature film, the cost of creating the film's soundtrack (roughly $27,000) was more than the actual filming budget (about $26,800).

The movie was made on a shoestring, with various friends of Kevin Smith's helping out. The boom operator is credited as "Whoever grabbed the pole".

Clue When the film was being screened at cinemas, only one ending was shown. Different venues got different endings. All of them are available on the DVD.

Conan the Barbarian The Mattel Toy Company was going to make some Conan the Barbarian action figures based on the film, but after viewing the finished product the Mattel executives realised that it would be inappropriate to release a line of toys based on a film loaded with graphic sex and violence. Instead, they gave their doll blond hair, called him "He-Man" and created "He-Man and the Masters of the Universe".

The Crying Game In Richard Corliss's review of the film in *Time* magazine, the first letters of each paragraph spelled out "She is a he", giving away the big twist.

Cube All the characters in the movie are named after famous prisons from around the world – Holloway, Leaven and

Worth (Leavenworth), Quentin (San Quentin), Kazan, Rennes and Alderson.

📽 *Dawn of the Dead* An alternative ending was filmed, in which Peter shoots himself in the head and Fran kills herself by sticking her head up into the rotating blades of the helicopter. The effects for the scene were never completed, but Gaylen Ross had had a mould of her head made up for the effects scene and Tom Savini did not want to see it go to waste. So he dressed the head up as an African-American man with a beard, which is the head that explodes from a shotgun blast at the start of the film. To get the right look for an exploding head, Tom Savini cleared everyone off the set and actually had the head blasted by a real shotgun using live ammo.

📽 *Desperado* Steve Buscemi and Cheech Marin's scenes had to be shot quickly as the production could only afford Marin for six days and Buscemi for seven.

📽 *Die Hard* One cop says that John McClane "could be a f***ing bartender for all we know". Prior to becoming a well-known actor, Bruce Willis actually was a bartender.

📽 *Die Hard with a Vengeance* How to solve the water-jug riddle. (Guaranteed to break the ice at parties.) They've got a five-gallon jug and a three-gallon jug – they need four gallons. Fill the five and tip it into the three, leaving two. Empty out the three, and put the two in it. Then fill the five, and use that jug to fill up the remainder of the three, which will leave four in the five-gallon jug. Another possible way to do this: you fill up the three and tip these three gallons into the five. Then you fill up the three and use this to fill up the five. This leaves you with one in the three and five in the five. Then you empty the five and tip the one from the three into it, then fill up the three. Then you've got three in the three and

one in the five. After you've tipped the three into the five this will leave you with four in the five.

🎥 *Dogma* At one point we see Silent Bob reading *USA Today*. Director Kevin Smith met his wife while she was writing an article for *USA Today* and interviewed him.

🎥 *Donnie Darko* The time when the world is supposed to end is 28 days, 6 hours, 12 minutes and 42 seconds in the future. Add all those numbers together and you get 88. The year in which the film takes place is 1988.

🎥 *Dr Strangelove* The ending was originally going to show a custard pie fight between the Russians and the Americans in the War Room. This is why there is a long table on which there are numerous pies. The scene was filmed but then cut from the final print. Stanley Kubrick decided not to let the sophisticated black comedy degenerate into a slapstick ending.

Kubrick originally wanted to make this a serious drama. During the screenwriting process he was confronted again and again with situations that were completely truthful and deadly serious, yet he was afraid that the audience would laugh at how absurd it all was. Like General Turgidson referring to General Ripper's sending an entire bomb wing to obliterate Russia as "overextending his authority". He eventually figured out that the only way to write it would be as a black comedy.

The centrefold model (Tracy Reed) in the *Playboy* magazine that Major Kong is reading also plays General Turgidson's "secretary" at the start of the film.

🎥 *El Mariachi* Due to the movie's very limited budget, Robert Rodriguez couldn't afford traditional equipment for smooth

movement of the camera, so to film those shots he sat in a broken hospital wheelchair and was pushed around.

Robert Rodriguez did most of the shooting and editing himself. As such, unusually there were no storyboards for this film, as he didn't have any other crew members to show them to.

🎥 *Eraser* A projectile hitting the air at "near the speed of light" (about 334,800,000 m.p.h.) would instantly vaporise in a huge, blinding flash from the ridiculously intense frictional heating that would occur at such an enormous velocity in the atmosphere. The energy released would probably kill the shooter and anyone standing near him. Makes for a good movie effect, though.

🎥 *Evil Dead II* After Ash has cut off his hand and placed it in the bucket he puts books on top to hold the lid down. The top book is Ernest Hemingway's *A Farewell To Arms*.

🎥 *Eyes Wide Shut* This film ended up in *The Guinness Book of World Records* as "The Longest Constant Movie Shoot". It took four hundred days from start to finish, and was Stanley Kubrick's last film – he delivered the final cut to the studio just four days before he died.

🎥 *Fantastic Four* A Fantastic Four movie was filmed in 1994 with no intention of releasing the movie to the public. The film's distributor, New Horizons, had had the Fantastic Four licence for some time and would have lost it if they hadn't made a movie promptly. When rumours circulated that Chris Columbus wanted to make a movie version of the comic, New Horizons scrambled to film their own version so that they could hold onto the licence for a few more years. The actors and most of the crew were initially unaware that the movie was never going to be released, but many of them began to suspect it when the director made no effort to

ensure any standard of quality in the film. The 1994 version continues to circulate via illegal bootlegs, in the same way as the *Star Wars* Holiday Special.

The Fifth Element When the priest states that he has a theory about the advancing planet near the beginning of the film, the president tells him that he has "twenty seconds". Cornelius gives his theory – which takes exactly twenty seconds.

A Fish Called Wanda John Cleese's character name, Archie Leach, was Cary Grant's real name (Archibald Leach).

Forrest Gump When Forrest tells Lieutenant Dan that he is going to be a shrimp-boat captain, Lt Dan says, "Yeah, and I'm an astronaut." The next movie that Tom Hanks and Gary Sinese made together was *Apollo 13* in which they both played astronauts.

The Goonies At the end, when the kids are on the beach and all the parents arrive, Data says something about a giant octopus. What is he talking about? This was a scene that got deleted but the line of dialogue stayed in.

Gremlins This film was originally intended and scheduled for a Christmas release (unsuprisingly, given its setting) but was rushed into production quickly when Warner Bros. realised that it had no major competition lined up against Paramount's *Indiana Jones and the Temple of Doom* or Columbia's *Ghostbusters* for the summer movie season.

Greystoke – The Legend of Tarzan, Lord of the Apes Although Andie MacDowell stars, her voice was actually dubbed over by Glenn Close.

Heat This is a classic movie but most people don't realise

that it's actually a remake. A few years earlier director Michael Mann made a TV movie called *LA Takedown* with a similar plot and featuring many of the same characters.

🎥 *The Hitchhiker's Guide to the Galaxy* The message from Ancient Magrathea was designed so that Simon Jones's head will appear in 3-D if the viewer happens to have a pair of old 3-D spectacles to hand.

🎥 *Indiana Jones and the Temple of Doom* Indiana was named after George Lucas's dog, Willie was named after Steven Spielberg's dog and Short Round was named after screenwriters William Huyck and Gloria Hatz's dog.

🎥 *The Island* Jordan Two Delta (Scarlett Johansson) sees a poster ad and a commercial for Calvin Klein featuring her sponsor "Sarah Jordan". Scarlett really did these jobs for CK before she made the movie.

🎥 *The Living Daylights* The "Red Cross" helicopter seen in this movie (registration G-HUEY) has an interesting history of its own. It is a Bell UH-1H that originally belonged to the Argentine Army, and it was captured by British forces at Port Stanley during the 1982 war in the Falkland Islands.

🎥 *Lord of the Rings: The Fellowship of the Ring* When Boromir is teaching Merry and Pippin to use their swords, you can hear him counting numbers as he delivers the blows to be parried. These numbers – "2, 1, 5" – are in fact the correct numbers for the system of parries used by the Society of American Fight Directors and many stunt co-ordinators and fight masters worldwide. Boromir even matches the numbers to the correct locations. The numbering system is supposed to have been based on historic European fencing manuals.

Lost Highway The budget for this movie was so small that some of the scenes were actually filmed in director David Lynch's own house.

M*A*S*H Approximately halfway through the movie there's a shot of the moon while an announcement is made over the PA system. This was filmed on the exact same night that the first humans made their walk on the moon.

The Matrix Reloaded For the famous freeway chase, almost every vehicle that was used was made by General Motors. GM donated about three hundred cars for use in the film. By the time filming was finished, almost all of them had been wrecked in some way.

Mean Streets While this is considered by many people to be a definitive New York film, very little of it was actually shot in New York City. Various scenes, including the famous pool-hall sequence, were really filmed in Los Angeles.

Mulholland Drive This was originally filmed for $8 million in 1999 as a made-for-TV pilot. Once it was decided not to follow it with a TV series, the French film studio Studio Canal provided an extra $7 million to film new scenes in order to tie up the ending, which had deliberately been left unresolved.

My Fair Lady Audrey Hepburn's singing was dubbed by Marni Nixon. Hepburn was extremely disappointed by this – she had prepared for a long time, and didn't realise that she was going to be dubbed.

Octopussy Maude Adams, who played Octopussy, is the only actress who performed the "Bond Girl" role twice. She was

seen previously as Scaramanga's mistress Andrea Anders in *The Man With the Golden Gun* in 1974.

Patton This film is most remarkable for its ironic choice of vehicles. All the "German" tanks in the movie are, in fact, American M48 "Patton" tanks borrowed from the Spanish army. This was probably the first and only time in history when a general fought – albeit unintentionally – to destroy his own namesakes.

Pet Sematary At the beginning of the movie there is a grave in the Pet Sematary that reads, "Smucky the Cat, he was obedient." Smucky the Cat was actually Stephen King's daughter's cat that got killed.

Phone Booth This movie took only twelve days to shoot. The scenes inside the phone booth were shot in ten days and the exterior shots were done during the other two days.

Platoon Johnny Depp's helmet has "Sherilyn" written on it – this was a tribute to Sherilyn Fenn, with whom he was going out at the time. In the scene where the soldiers are smoking dope there is another reference to her: the carved initials "SF." can be seen on the guitar that Johnny Depp is playing.

The Player The celebrity cameo appearances were not actually written into the script – Robert Altman added them all as filming progressed. No celebrity who had a cameo was given any scripted dialogue. It is estimated that, if all the celebrities who had a cameo in this movie had charged their normal asking prices, the film's budget for salaries alone would have been well over $100 million.

Psycho Alfred Hitchcock didn't want the ending of the movie given away, so after buying the film rights he bought every

physical copy of the Robert Bloch novel that he could find so that no one would be able to read it and discover in advance what happens.

Raging Bull This was going to be just one of eight different boxing movies to come out in 1980. In order to make it different so that it stood out from the crowd, Scorsese decided to film it in black and white. He also spurned the idea of filming the boxing scenes using multiple cameras. Instead, for several months he planned and carefully choreographed movements in the ring with just one camera. He wanted the single camera to be thought of as "a third fighter".

Requiem for a Dream In the scene where Harry and Marion talk on the phone, rather than shooting both sides of the conversation separately both actors were shot simultaneously on parts of the same set that were next to each other, using a working phone system, so that real reactions could be used.

Reservoir Dogs Mr Blonde's car really belonged to Michael Madsen. The film's budget was too small for Quentin Tarantino to buy a separate car for the Blonde character.

The Ring In the original version there were scenes featuring a child-killer (played by Chris Cooper). Early in the movie the killer begs Rachel to write a story saying that he is rehabilitated and deserves to be freed, and she refuses. At the end of this version of the movie Rachel would have been seen sending the copy of the tape she made to him.

Scarface Even director Brian De Palma claims not to know whether the "cocaine" that Al Pacino sniffs towards the end of the film was real or not. Al Pacino has been asked this question himself many times, but he simply replies that he would prefer not to answer, as "it would take away someone's belief of it".

Se7en All John Doe's books were actually written for the film, taking two months to complete at a cost of $15,000. At one point in the film Morgan Freeman makes a reference to this, saying that it would take the police two months to read them all.

Shallow Grave The budget was so limited for this film that the film-makers had to auction off various props once they had finished with them so that they could raise enough money to buy the film needed to finish the shoot.

The Shining The real Overlook Hotel is near Portland, Oregon. It has no Room 237 because the owners specifically requested that a fictitious room number should be used, believing that after people saw this movie (or read the book) no one would want to stay in that room.

Sid and Nancy The chain necklace worn by Gary Oldman actually belonged to Sid Vicious. Sid's mother gave Oldman the necklace to wear after meeting him while he was researching.

Signs The stories of the children's births are actually the stories of M. Night Shyamalan's two children's births.

Sin City Quentin Tarantino directed the scene with Clive Owen and Benicio Del Toro talking in a car. He was paid one dollar.

Sixteen Candles Jake's licence plate reads "21850" (Feburary 18, 1950), which is director John Hughes's birthday.

Spider-Man 2 When Peter hits the ground after failing to clear the building, he gets up and complains about his back hurting. Tobey Maguire almost didn't reprise his role as Spider-Man because of a back problem.

🎥 *Star Wars* Most of the Imperial Stormtroopers appear to be left-handed. This is because of how the weapons are constructed – the blasters are based on a real gun, with the magazine on its left side. This design caused the weapon to hit the troopers on their chests when they carried them so they ended up having to hold them in a different way.

🎥 *Star Wars: Episode VI – Return of the Jedi* Most people today know what an Ewok is, despite the fact that the word is never actually spoken in the film.

🎥 *Straw Dogs* The title of this film comes from the Chinese philosopher Lao-tzu. He wrote: "Heaven and Earth are ruthless, and treat the myriad creatures as straw dogs; the sage is ruthless, and treats the people as straw dogs."

🎥 *Superman IV: The Quest for Peace* Near the end of the film, Superman gives a press conference in front of a bluish mirror-glass building which is meant to be the *Daily Planet* skyscraper in Metropolis. The shot is framed so that only the bottom of the building is seen – necessary since the real building is only about three storeys high, and is in fact the railway station in Milton Keynes, England. New York was too expensive to shoot in.

🎥 *The Texas Chainsaw Massacre* Only one person actually gets killed with the chainsaw: Sally's brother.

🎥 *The Third Man* Orson Welles didn't want to film the scenes in the sewer and left the production before they could be completed. The shot near the end in which Harry Lime's hands reach for the sewer grating actually features the hands of the director, Carol Reed.

🎥 *Three Kings* Tony Gardner, the make-up-effects artist on

this film, was investigated by the Arizona State Police for the work he did on this film involving a bullet that is seen travelling through a soldier's body. The police originally thought that bullets had been fired into a real human corpse and filmed with a high-speed camera. Eventually Gardner had to write a disclaimer describing exactly how he had achieved the sequences by using make-up-effects technology. Warner Brothers then gave out the disclaimer to all those who were inundating their offices with enquiries.

Total Recall When Arnold Schwarzenegger is dressed up as the fat lady, the passport that he hands to the guard is the actual passport belonging to Priscilla Allen, the actress who plays the fat lady.

Towering Inferno Stars Paul Newman and Steve McQueen apparently argued intensely over who should get top billing. In the end the producers settled for a compromise: reading the film poster (which is reproduced as the DVD cover) from top to bottom, Paul Newman's name is first, i.e. he has higher or "top" billing. But reading left to right, Steve McQueen comes first. The same applies to their photographs at either side of the main artwork: McQueen is on the left but Newman is (marginally) higher up.

Twister This film was the first movie ever released on DVD.

The Usual Suspects The Hungarian who slits Keyser Soze's son's throat is the stuntman who did all Peter Sellers's stunts in the *Pink Panther* movies.

Five actors ended up playing the part of Keyser Soze: we see both Gabriel Byrne's and Kevin Spacey's faces; in the flashback sequence, Keyser Soze is shown as a man with long hair covering his face; when we see Keyser Soze's hand lighting a cigarette, the hand

belongs to John Ottman, the composer and editor for the film; and for the close-up of Keyser's feet director Bryan Singer used himself.

🎥 **Wayne's World 2** The story that the roadie keeps telling, about Ozzy Osbourne demanding a brandy glass filled with brown M&Ms, is actually based on true events. Van Halen really did have a list of items that they would insist on having from any concert venue – towels, catering, stage-equipment requirements, etc. This included a bowl of M&Ms backstage, with all the brown ones removed. The reason for this particular absurd demand wasn't irrational pickiness – it was to ensure that the entire list, which most importantly included safety measures for the band's unusually large and heavy stage set, had been read and obeyed to the letter. Sure enough, at one show the list wasn't followed and the staging set-up crashed through the floor.

🎥 **Willow** Although it's not mentioned in the film directly, the press kits and the novels based on the film name the two-headed dragon as "Eborsisk", after the two movie critics Gene Siskel and Roger Ebert.

REUSED CONTENT

Ever watched a film and thought that you recognised a location, a costume or even some dialogue? Most likely it's not déjà vu – you'd be surprised just how often an old set gets a new lease of life . . .

The Abyss The pictures that accompany the news report of the collision between US and Russian ships are actually from the Falklands War. They're of British task-force ships that were attacked.

Air Force One The Russian prison seen a few times during the film is actually the Mansfield Penitentiary. It was also used as the prison in *The Shawshank Redemption*.

Alien In the beginning, inside the *Nostromo*, on one wall there is a Krups coffee grinder. This is the same bit of equipment used as the basis for "Mr Fusion" in *Back to the Future*.

The actress Veronica Cartwright, who plays Lambert, said in an interview that when the alien's tail wraps around her legs they are not her legs at all. That shot was originally supposed to be for a completely different part of the film, and the legs seen belong to Harry Dean Stanton who played Brett.

Aliens A lot of the hardware used by the colonial marines is the same hardware used by the humans in the original *The Terminator*. Some of the guns, the flashlights (which are just roadside emergency lights) and some of the armour were all reused.

American Pie The dinner jacket that "The Sherminator"

wears to the prom at the end is the same one that Steve Buscemi wears as the drunk best man in *The Wedding Singer*.

Back to the Future The set used as the town of Hill Valley was also used as Kingston Falls in *Gremlins*.

Back to the Future Part II The opening shots of clouds were originally filmed for *Firefox*, starring Clint Eastwood and released in 1982.

Much of Griff's outfit, particularly his boots, are bits of Klingon costumes from *Star Trek: The Next Generation*.

Batman The horrific plastic-surgery tools on display during the scene when The Joker sees his face for the first time were previously used by Steve Martin's maniacal dentist in *Little Shop of Horrors*, another Warner Bros. production.

Before Sunrise The Ferris wheel on which Ethan Hawke and Julie Delpy take a trip in Vienna is the same one seen in *The Third Man* and *The Living Daylights*.

Big Fish The door to the vault seen during the bank robbery is the same one used in *Batman*, on the vault that contains the Batsuit.

The machine for making breakfast that the young Ed Bloom exhibits at the science fair is the same machine seen in *Pee-wee's Big Adventure*, also directed by Tim Burton.

Bill & Ted's Bogus Journey The location where evil Bill and Ted try to kill the real Bill and Ted, a rock face, is the same rock face that Captain Kirk is standing on in the scene from *Star Trek* seen on TV earlier in the movie.

ⓒ *Carlito's Way* The outside of the hospital where Carlito visits his lawyer is the same hospital that Don Corleone is taken to in *The Godfather*, which also starred Al Pacino.

ⓒ *The Chronicles of Riddick* In the opening scenes of the movie there are several massive statues representing necromongers. These are also in the film *Batman*. They are right in front of the building when the goons announce that they will be running Jack Palance's company.

ⓒ *Coming to America* The greater part of the dance performed by the royal dancers before Prince Akeem's future queen is presented to him is a faster version of the dance from Michael Jackson's classic *Thriller*, which was also directed by John Landis.

ⓒ *Commando* A sequel idea was considered, but Arnold Schwarzenegger was not interested. The idea eventually became *Die Hard*, three years later. Schwarzenegger is still mentioned in the line "Enough plastic explosive to orbit Arnold Schwarzenegger", spoken by Bruce Willis.

The shopping mall used in this film is the same one used in *Terminator 2*.

The large mansion used for the final battle between Matrix and Arius is the same house seen in *Beverly Hills Cop*, used in the shoot-out between Axel Foley and Victor Maitland.

ⓒ *Desperado* The same "penis gun" that is used in *From Dusk Till Dawn* is in Antonio Banderas's guitar case.

ⓒ *Die Hard* The teddy bear that Bruce Willis brings to his son is the exact same bear that Alec Baldwin brings home to his daughter at the end of *The Hunt for Red October*, which is another John McTiernan film.

The truck in which the terrorists arrive has "Pacific Courier" on the side, and is is mostly green with a white roof. In *Die Hard with a Vengeance* a similar truck is seen, caught up in the explosion at the beginning – identical colours, but with "Atlantic Courier" on the side (this film takes place on the other side of the country). The company also appears in *Speed* – the plane that explodes towards the end after the bus hits it is green with "Pacific Courier" on the side. Production designer Jackson De Govia was a member of the crew for all three films.

For Your Eyes Only The amazed extra from the beach in *The Spy Who Loved Me* and the surprised guy in St Mark's Square in *Moonraker* gets another eyeful when Bond skis through his dinner.

Forbidden Planet To save money, many of the set backdrops in this film were recycled from *The Wizard of Oz*. This is most obvious in Morbius's garden.

Four Weddings and a Funeral If the church where Charles nearly marries Henrietta looks familiar, that's because it's the same church where the Sheriff of Nottingham attempts to force Maid Marion to marry him in *Robin Hood: Prince of Thieves* – St Bartholomew the Great in London.

Ghostbusters The old firehouse used as the Ghostbusters' HQ is actually two different buildings on opposite sides of the US. When shown from the outside the building's in New York, while the interior is an old firehouse in LA. The New York one can also be seen in *The Mask*, as the garage where Jim Carrey gets ripped off before attacking it.

Gladiator At the beginning of the film when the Romans and Germanians are about to do battle, some of the chants from the Germanians are taken from the soundtrack of the 1963 film *Zulu*.

🎥 *Godzilla* (1998) Two lines previously spoken on film by Luke Skywalker are reused the first time the attack helicopters chase Godzilla through the New York streets. The line "Echo 4 to Echo Base" comes from *The Empire Strikes Back*, and "He's right on my tail! I can't shake him!" comes from *Star Wars*.

🎥 *Gone With the Wind* The "Burning of Atlanta" scene was shot long before filming started on *Gone With the Wind* and, indeed, before either of the actors for the roles of Rhett and Scarlett were cast. The purpose of this was to clear the MGM lot so that the sets for the movie could be built. The buildings being burned were sets from other films, the most noticeable being the huge gates featured in the original *King Kong* movie. The two actors in this scene were simply stand-ins who doubled for Vivien Leigh and Clark Gable.

🎥 *Hannibal* The mansion in which Mason Verger lives was also used as the mansion in *Richie Rich*. Two rather different cinematic inhabitants . . .

🎥 *Harry Potter and the Philosopher's Stone* The street that Harry and Hagrid walk down to get to the Leaky Cauldron is the same street in which Sean Connery is parked while he's waiting for Catherine Zeta-Jones to leave the antiques shop in *Entrapment*.

🎥 *Heathers* The kitchens used in Heather Chandler's and Heather Duke's houses are the same room, but with different lighting and camera angles.

🎥 *Hollywood Homicide* When Harrison Ford is walking through the old guy's mansion, there is a shot of the two of them walking down a hallway. This is the same shot (and the same house, for that matter) that was used in the movie *Fletch* when Fletch was talking about how Hopalong Cassidy used to live in the

house. The front of the mansion with the fountain in the middle of the circle driveway is also recognisable.

The Hunt for Red October The double beep used when the *Red October* moves across the USS *Dallas*'s sonar screen was reused in the later Jack Ryan film *Patriot Games* as the sound of his heart monitor when he's in hospital after getting shot.

The Incredibles The flying spinning-blade vehicles used for the chase scene through the jungle sound identical to the speeders in *Return of the Jedi*.

Jackie Brown The suit that Jackie Brown buys is the same one that Mia Wallace wears in *Pulp Fiction*.

The white Honda that Jackie drives is the same one that Butch is driving in *Pulp Fiction* when he runs down Marcellus Wallace.

Jaws After the shark blows up and is shown underwater there is a sound taken from *Creature from the Black Lagoon*. It was also used when the truck was falling off the cliff in *Duel*, another Spielberg movie.

Kill Bill: Volume 2 The car that Darryl Hannah drives is the same type as Burt Reynolds's Trans-Am from the *Smokey and the Bandit* films. At one point during shooting she was driving along with Quentin Tarantino in the passenger seat when he excitedly yelled, "Pull off here!" and pointed down a dirt track. She fishtailed the car down the road, going at a fair old speed, when she suddenly noticed that she was heading straight for a hole. Quentin yelled, "Jump it. It's just a movie – nothing can happen." Choosing common sense Ms Hannah squealed to a halt just in front of the hole. Tarantino's comment? "Burt Reynolds would have jumped it."

The flute that David Carradine ("Bill") uses in this film is the actual flute he used in the original *Kung-Fu* TV series. He brought the flute along to rehearsals and Quentin Tarantino wanted to find a way to include it.

🎥 *Lethal Weapon* The house that gets blown up was also used as the family home in *The Partridge Family* and the Kravitzes' home in *Bewitched*.

🎥 *Little Nicky* When Nicky stops to smell the flowers, you can see the restaurant from the TV show *Seinfeld* in the background.

🎥 *The Matrix* Lots of the sets from *Dark City* were reused, such as rooftops, buildings and other exteriors. The rooftops that Trinity runs along at the start of the film are the same ones that John Murdoch runs across in *Dark City*.

🎥 *Ocean's Eleven* The wig that Brad Pitt wears when he's disguised as the doctor was used in rehearsals for the first of the *Austin Powers* movies.

🎥 *Old School* The café used for the scene when Mitch is speaking with the girl he likes has also been used in *Se7en*, *Training Day*, *Fight Club*, *Gone in 60 Seconds* and *Ghost World*.

🎥 *Planet of the Apes* (2001) The ape policeman at the end of the film wears a helmet originally used in *Starship Troopers*, with an added visor and the helmet itself painted black.

🎥 *Raiders of the Lost Ark* The canyon where Indiana confronts Belloq and the Germans and threatens to blow up the Ark is the same canyon where the Jawas take R2-D2 in *Star Wars*.

The German U-boat in this movie is actually a mock-up built for Spielberg's earlier movie *1941*. Only the front half of the sub was constructed so there is no view past the conning tower in close-ups. When the sub is shown in its entirety it's a model that was also built for *1941*.

🎥 **Se7en** The café where Morgan Freeman and Gwyneth Paltrow talk is the Quality Café, the same place where Nicolas Cage's mother worked in *Gone in 60 Seconds*. The interior is the same as well, just shot from a different angle.

🎥 **Sin City** Miho's swords are the same ones carried by some of the Crazy 88s in *Kill Bill: Volume 1*. The prop designers asked Tarantino if they could borrow them (he'd been keeping them in his garage) and he let them.

🎥 **Sky Captain and the World of Tomorrow** When Polly is reporting the advance of the giant robots on the phone to her editor, she says, "They've reached Sixth Avenue . . . they've reached Fifth Avenue . . . they're a hundred yards away . . ." This is an exact copy of a line from Orson Welles's famous 1938 radio adaptation of *The War of the Worlds*.

🎥 **Terminator 2: Judgment Day** There was originally going to be a scene involving the Time Displacement Machine, which was used to send The Terminator and Kyle Reese back in time in the first film. The machine was designed, but the idea was eventually ditched as it was deemed too complicated and not essential for the plot. However, the machine's design ended up reappearing in 1997 as the capsule that Jodie Foster uses to travel through space in *Contact*.

🎥 **They Live** In the television station the SWAT team members use radios that look exactly like the PKE meters from *Ghostbusters*.

Training Day The scene at the start of the movie where Ethan Hawke meets Denzel Washington is the same diner where Morgan Freeman meets with Gwyneth Paltrow in *Se7en*.

True Lies The place where Jamie Lee Curtis meets Bill Paxton is the same place where the T-1000 arrives in *Terminator 2*, also directed by James Cameron.

The World is Not Enough The castle that was used in the film as the location for MI6's headquarters in Scotland was also used extensively in the film *Highlander*.

THE WILHELM SCREAM

![TAKE 20]

The "Wilhelm scream" was first used in the film *Distant Drums* in 1951 (there are actually a few different takes, all equally recognisable). While reused a few times in the 1950s and 1960s, it started to become more widely recognised when it was used in *Star Wars*. The sound designer on that film, Ben Burtt, found the original recording on a reel of film labelled "Man being eaten by alligator". The name Wilhelm came from the character who uttered the scream in *The Charge at Feather River* in 1953. The scream had a nice return to its origins in *Indiana Jones and the Temple of Doom* in 1984, when it was used while the principal villain was actually being eaten by alligators.

It now seems to be more popular than ever, featuring in many different films, always seemingly included as an in-joke by the sound crew. Listen carefully the next time a blood-curdling scream crops up on screen and you'll probably find quite often that it's the Wilhelm. Listing every example of it would take quite a bit of space, but here are some of the more famous instances:

Attack of the Clones – at the beginning of the film, when a ship explodes on Coruscant.
Batman Returns – as Batman punches a clown and tosses him aside near the start of the film.
Die Hard: With A Vengeance – while driving through Central Park Zeus asks McClane if he is intentionally trying to hit people. McClane replies, "No . . . maybe that time." After he says "no" the Wilhelm can be heard.
Fantastic Four – there are two screams during the Thing/Dr Doom fight, one as the car and Doom plough into the bus, and another one shortly after.
Gremlins 2 – when someone with gremlins all over him falls off a ledge.

Kill Bill: Volume 1 – there are two instances during The Bride's fight with the Crazy 88s when the scream can be heard.

Kingdom of Heaven – when the Christians fire their first volley at the Muslims, one of the guys screams a Wilhelm as he falls.

Lethal Weapon 4 – after Riggs shoots the valve on the napalm tank being worn by the criminal with the flame-thrower at the start of the film, the legendary scream can be heard as the criminal goes flying.

Lord of the Rings: The Return of the King – the scream makes an appearance during the scene where Faramir's men are fleeing from Osgiliath across the Pelennor Fields. Just after the people of Minas Tirith call out, "The White Rider!" a Nazgul swoops down and snatches up one of Faramir's men. The Wilhelm is heard as he falls. Another Wilhelm scream can be heard when Legolas is climbing the Oliphaunt and throws one of the Haradrim off.

Planet of the Apes (2001) – when General Thade throws two people into the air at once.

Raiders of the Lost Ark – during the truck chase, a Nazi soldier falls from the back of the truck, ripping the canvas.

Reservoir Dogs – there are two Wilhelm screams in the movie. One is when Mr Brown is shot. The second is when Mr Pink pushes someone out of the way when running from the cops.

Return of the Jedi – with his lightsabre Luke cuts down someone who falls into the Sarlacc pit.

Shaun of the Dead – the zombie that Ed kills with the ashtray emits the famous scream.

The Siege – after the terrorist blows up the theatre, you can hear the scream.

Sky Captain and the World of Tomorrow – a construction worker on scaffolding which is destroyed by the batlike flying thing pursuing Joe and Polly through New York City lets out the scream as he falls.

Star Wars – when a storm trooper falls into the chasm on the Death Star before Luke and Leia do their death-defying swing.

The Empire Strikes Back – during the Hoth battle when a rebel soldier's emplacement is hit and explodes.

The Phantom Menace – used by two security officers in the shoot-out in the Naboo hangar.

Toy Story – when Buzz Lightyear gets knocked out of the bedroom window.

Troy – keep an ear out for two Wilhelm screams – the first when the second Myrmidon falls overboard into the water after being hit by Trojan arrows, the second moments later, when Achilles and his Myrmidons are in their shield formation. One Myrmidon stands behind the formation and fires an arrow into a Trojan, who screams a Wilhelm as he falls.

MISQUOTES AND MORE MOVIE MYTHS

Lives of a Bengal Lancer (1935) saw the first use of the line "We have ways of making men talk", which is often misquoted as "We have ways of making you talk."

"A man's gotta do what a man's gotta do" is often associated with John Wayne, but is actually spoken by Alan Ladd in *Shane*.

Mae West never spoke the line "Come up and see me sometime" – the line was "Why don't you come up sometime and see me?", from *She Done Him Wrong* in 1933.

Rick never says "Play it again, Sam" in *Casablanca*. The closest lines to this are when Rick says, "You played it for her, you can play it for me. Play it!" and when Ilsa says, "Play it, Sam. Play 'As Time Goes By'."

Casablanca is the source of another great misquote – the final line "Louis, I think this is the beginning of a beautiful friendship" is often misremembered as "This could be the beginning of a beautiful friendship" or "I think this is the start of a beautiful friendship."

"Go ahead, make my day" doesn't feature anywhere in the original *Dirty Harry*, contrary to popular belief. It didn't appear until the fourth film in the series, *Sudden Impact*.

3 Men and a Baby – allegedly there's a ghost of a small boy visible in the background when Ted Danson's talking to his mother. Some people insist that it's the ghost of a child who died in the apartment where the scene was filmed. The truth's rather more mundane – it's a set, not an actual apartment, and the shadowy figure is a cardboard cut-out of Ted Danson.

Fargo – despite the claim that it's "based on a true story" that's

purely a narrative device, as proved by the standard disclaimer at the end about "no resemblance to any persons living or dead ..."

It's frequently mentioned that all the clocks in *Pulp Fiction* are set to show 4:20. However, in at least two scenes this is definitely false. In the "Bonnie Situation" when Jimmy, Vince and Jules are having coffee in the kitchen, the clock clearly shows 8:15. Also, when Vince and Jules go to get the briefcase it is "7:22 in the a.m." All the clocks seen in the pawn shop are set to 4:20, but that's the only instance.

ABOUT MOVIEMISTAKES.COM

Back in September 1996 I was seventeen years old, a huge film fan and fairly computer-obsessed. I wanted to make a web page, but couldn't really think of what to do. I eventually took a few continuity mistakes and film facts, put them into a website along with an e-mail address, and that was about it. I never really expected many people to look at what was then called "The big list of movie mistakes" (innovative, I know), but, as part of the learning experience, I submitted the page to search engines, swapped links with people, and spread the word to everyone I knew, just to see how my traffic did. At first I got visits from a few people a day, at most, but those people submitted new entries, which made the site that much bigger.

By 1999, the website had more than two thousand entries and was getting about eight hundred hits a day. One day an article about it appeared on the news service Reuters, and the resulting exposure caused a tripling in traffic. I registered a proper domain name, moviemistakes.com, which further boosted traffic (it's a wonder what an easy-to-remember name will do for you) and people kept on coming in. At the time of writing, the site has over fifty thousand mistakes from more than four thousand different films. About thirty thousand people a day visit the site, but if a major new release turns out to have more than its fair share of blunders that can jump as high as a hundred and twenty thousand

INDEX